C000275740

What a Life!
50 Years of Fleet Street Photography

Ted Blackbrow

Whittles Publishing

Published by
Whittles Publishing Ltd.,
Dunbeath,
Caithness, KW6 6EG,
Scotland, UK

www.whittlespublishing.com

ISBN 978-084995-223-1

Production Managed by Jellyfish Solutions Ltd.

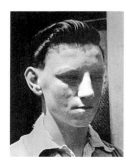

1954/2016

Throughout my career I was constantly disappearing at a moment's notice to travel around the world. Sometimes the office would not tell my wife where I had gone in case she gave the game away! Through all of this she and my children were always there to welcome me home.

So I have to thank them – Dolly, Peter, Jennifer and Caroline – for making my career possible.

This book is for them.

Contents

Foreword ... ix

Introduction – The 60s ... 1

The Nuns' Story ... 7
Travelling Stars .. 10
Heathrow Glamour in the 60s 15
Royals ... 22
Chinese street riots ... 25
The Shah's Coronation .. 29

Introduction – The 70s .. 32

Roger Moore's wedding .. 34
TVR nude models .. 35
Women soldiers ... 37
Enoch Powell ... 39
Keith Castle ... 41
Mick Jagger ... 44

Royal wedding ... 46
Sean Connery in East Berlin 48
Boat People ... 51

Introduction – The 80s .. 55

Christopher Reeve ... 57
Peggy Lee .. 58
Archbishop Runcie .. 60
Beetle cars ... 62
Ski car racers ... 66
Mrs Gandhi .. 70
Charles and Diana's Wedding 72
Margaret Thatcher .. 75
No 10. 'Maggies Den' .. 78
Queen Mother ... 80
Pantomime with Elton John 82
Marie Helvin ... 84

Diana Ross ... 87

Bluebell Dancers at the Lido 90

Prince Andrew and Sarah Ferguson 92

Reagan and Gorbachev 97

Glenn Close .. 100

Passion for Fashion ... 102

Anarchy on Westminster Bridge 105

Eddie the Eagle .. 110

Seoul Olympics .. 114

Ian Wooldridge ... *124*

Snooker in the Desert 131

Introduction – The 90s *135*

Sharron Davies .. 139

Snowflake ... 141

Seve Ballesteros .. 144

Steve Backley .. 147

Linford Christie ... 149

Tonya Harding ... 151

Brian Lara ... 154

Roger Bannister ... 156

Jack Charlton .. 157

Paul Gascoigne .. 159

Steve Redgrave ... 162

The Barnsley Bride .. 164

Tiger Woods ... 166

Newmarket ... 169

Moldovan orphan .. 172

Introduction – The 00s *175*

Wallace .. 176

Terrence ... 178

Pregnant boxer .. 180

Robins .. 181

Pigs vs Seagulls ... 182

Babe in arms ... 184

Diana: A short sad life *187*

Final Words .. *191*

from
Paul Dacre
Editor-in-Chief, Daily Mail

As an editor will tell you, a picture is worth a thousand words. For 37 years Ted Blackbrow gave the *Daily Mail* pictures that told a story in a way no mere wordsmith – and he worked with the very best – could hope to emulate. They are all here in this wonderful book; from a not-yet-famous Mick Jagger flying out of Heathrow (Ted thought he was Manfred Mann, but that's another story), to a haunting shot of Prince William walking, head bowed, behind his mother's coffin.

A child of the East End – complete with outside toilets and weekly visits to the baths – Ted's career began in a war-battered Fleet Street with plate cameras that only allowed two shots a minute... modern digital camera motor-drives capture 14 a second. But while he may have lacked technology, he was never short of ingenuity or creativity. One of his most enchanting sets of pictures is of two young nuns, going through their ceremony of 'marriage to Christ'. The story of how the pictures came to be taken is just as intriguing.

Ted's own greatest partnership was with the *Mail*'s legendary sports writer Ian Wooldridge. In a world where pictures were not snatched, but carefully and imaginatively composed, Snooker in the Desert – with Steve Davies, Stephen Hendry and an obliging camel – is a masterpiece of the genre.

The world is a different place now. Just how different is the story of Ted's pictures...

Foreword

You always knew where you were with Ted Blackbrow. Straight talking, hard-working, fun to be with and crucially, one of Fleet Street's finest photographers.

Not bad for a boy whose headmaster in London's East End thought Ted would make a good dustman when he forced him to leave grammar school as a 15 year-old.

'What a Life' is an apt title for Ted's incredible subsequent journey of more than five decades that began with a borrowed camera photographing his beloved Leyton Orient and ended with him so brilliantly capturing sporting history at the Olympics and World Cup.

Along the way he sat down with Royalty, chronicled Reagan's fraught meetings with Gorbachev – just two of the world leaders he photographed – illustrated the highs and lows of sporting superstars as well as guiding us in pictures through the Swinging Sixties and beyond.

At heart an accomplished and brave news man, he also had a rare ability to take the stars beyond their comfort zones persuading Steve Davis and Stephen Henry to play snooker in the sweltering Dubai desert while one of his most extraordinary journeys involved taking Sean Connery through East Berlin at the height of the Cold War, even giving the secret police the slip long enough to take his pictures.

It is the stories and anecdotes behind these pictures that provide a fascinating insight into a top photographer's life 'on-the-road' and Ted's unrivalled ability to see or engineer opportunities for exclusive, unique, prized photographs that would distinguish many a front or back page.

The volume and variety of work in this book showcase not only Ted's talent but his all-round ability. Once when a 'society' photographer hearing Ted was from Fleet Street condescendingly described him as a 'jack of all trades', he retorted : 'If that means I can do everything you do, and more, then yes I am.'

It was the way it was with Fleet Street's finest.

David Williams
Chief Reporter, Daily Mail

Introduction – The 6os

This was where it all started, at my old school, Davenant Foundation School on the Mile End Rd, Stepney. This picture reminds me of the residents of the nearby Salvation Army's Booth House hostel, who always sang a hymn before eating. One of their favourites, and mine, was "What a friend we have in Jesus"; they were singing that when I was thrown out by my late headmaster.

The image of my son Peter playing on the street in Stepney, where we lived in the top rooms of my mother's house, was taken in the early part of 1963; I was testing my new Rolliecord Camera. My wife was just behind me as we encouraged our son to throw the ball, and she worried that the dog, Wendy, would jump on Peter and lick him. I assured her that even if it did, the dog would survive!

This simple image was published in two of the three London evening newspapers of the day. On a Saturday morning the papers would use this type of image in their early editions, and then throw them out as the sports pictures came in.

To me the picture is a time capsule. If you look you will notice the lack of traffic on the street – hardly anybody in the East End could afford a car. At the top of the image is Commercial Road, the main road to the docks which contained the East London Maternity Hospital where Peter was born. It's all gone now but I remember it well.

The pictures and events illustrated in this book are the story of my life from 1954, when I was thrown out of my old school, Davenant Foundation Grammar in Whitechapel, London for a complete lack of interest in the academic side of education. I had one interest – football. I had been convinced for years that I would be good enough for the professional game; I always held my place in the school teams, so it was quite a shock to discover that I was only an average footballer.

These pictures are time capsules that take me back
53 years to the start of my married life in Stepney.
The white building behind the dog is Holland's Pub,
the favourite drinking hole of my grandfather and
uncles at Christmas or on birthdays. The large
white building jutting out behind my son is the
public baths, where once a week if we were lucky we
could soak quite happily (more hot water in number
six please!). None of the houses had a bathroom,
running hot water or an inside toilet.

The engraving of my old school, Davenant Grammar
School, Whitechapel, shows the main hall, which still
stands. From the third arch on the staircase up to the
hall daily rollcall took place as we trooped up.

Can you imagine a London evening paper
using such a simple picture as Peter and Wendy
today? With the march of time those simple
days are long gone. I still miss them.

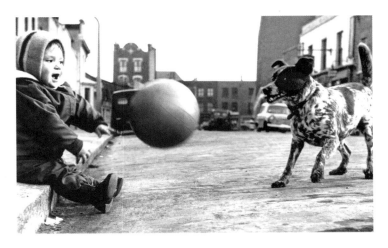

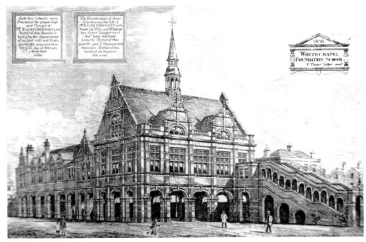

As I left the headmaster's office with my parents, I was close to tears, as was my mother. His withering indictment rung in my ears, 'Take him to the local council, where they might employ him as a dustman', and I had to admit I deserved it.

I tried to get a job, any job, with a professional football club; I would have been happy to clean toilets just to be around my heroes, but thankfully none of them wanted me, so I had to find a Plan B.

My dad had been taking me to Leyton Orient matches from when I was eight years old, the first team one week and the reserves the next. These were great days out; two tube trains to Leyton station, a long walk down the hill and then standing in the West Stand where my dad would meet up with his friends who supported the visiting teams. These were wonderful, innocent times when football supporters could stand together and not try to punch the living daylights out of each other.

I was fascinated by the group of men who sat either side of the goals with their big plate cameras – they had the best seat in the house! Then at half time they trooped off, sometimes chatting to the players, for a cup of tea in the warm and dry, while we poor perishers braved the cold and rain in the open stands. It didn't take me long to decide that this might be where I could earn a living, this was my Plan B, but how would I get in?

It was my mother who solved the problem when she spotted an advert in the *East London Advertiser* for messenger boys willing to work hard and learn the trade. It was placed by a Fleet Street picture agency with the exciting name of Planet News, which turned out to be the London office of United Press International, one of the two biggest picture agencies in the world. I was given an interview, spent three ha'pence on a no. 15 bus, and was transported into the very exciting world of Fleet Street. It was the start of a journey that would take me round the world to meet royalty, film and sports stars, and lead a life I had never dreamed of.

Fleet Street was still recovering from the war and there were bomb sites everywhere. If you cared to stroll up to St Paul's the enormous site next to the Cathedral had been flattened, and was still years away from the Paternoster Buildings to come. Planet News was tucked away at the head of Johnson's Court, reached by an underwhelming stroll that had the backs of the next court on one side, and a huge 40 foot hole on the other – the largest bomb site in Fleet Street.

The London bureau manager was a white haired gentleman called Leslie Hull who wore tinted glasses and dominated a small office on the fourth floor of the building. I was very impressed until he asked for my last school report. Shame and embarrassment flooded through me as he read it, and I prepared to leave with my tail between my legs. He asked me why I had not tried at school, and what I hoped to

Yours truly, complete with short jacket, plastic collar, regimental tie and winklepickers. Did I really look like that?! It was 1960, the year I got married. The quiff had been replaced by the Italian haircut, skiffle was king and rock and roll about to sweep the land. The housing was in a poor state with padded outside pipes and the toilet in the garden.

achieve in Fleet Street. I was very honest and explained about my footballing dreams and told him my greatest ambition was to photograph a Leyton Orient match in front of my dad. He informed me that the job he was offering was low paid (£2 9s 1d a week) after tax and that I would have to run prints round the street to the waiting picture desks – in all weathers. There would be a half a crown rise every three months. I was in!

Provincial newspapers had their offices along the entire street: *Liverpool Post, Yorkshire Post, The Scotsman* with its life-size statue of Mary Queen of Scots, and many others. It was the custom to have chalk boards with hot news items in the windows, and on my first stroll up to Johnson's Court and Planet News, I read the messages and enjoyed the excitement in the air. This was a few weeks after Dr Roger Bannister had run the mile in under four minutes, an incredible milestone, and it sent a wave of excitement through me.

Inside the agency on the ground floor were three huge hot, noisy, aluminium drums. If you were on print duty you had to take piles of wet prints from the darkroom sink and feed them onto the drums' moleskin belts. They would be dragged round the hot surface and emerge as shiny finished prints a couple of minutes later, ready to be whisked off round the street, or placed in the slots for foreign newspapers and posted late each evening in King Edward post office.

My job in those opening days was to run those prints round to the *Star, News* or *Standard* evening paper picture

desks as soon as possible. Each agency, and there were about 15 in the street, made their money from publication fees, and on edition times the first prints were often the ones they used. This led to lots of fun and games between the "runner boys"; the old *Evening News* had a very antiquated Victorian lift that was a listed feature of the building. The lift was very tempting to use, since the picture desk was on the fifth floor, but the boys from Planet were forbidden because if you went to the first floor as the lift was ascending, a quick pull on the doors had the lift stuck between floors. I can still recall many a scream of anguish from rival runners as I ran laughing past them to the picture desk.

I spent six months happily running up and down the street, enjoying a different life from people like my dad and brother, who held down good, honest, boring jobs. My brother confessed to me after he retired that he had always wanted to do and be where I was. Mine was the most menial job on the agency but it allowed me to mix and talk with the agencies' top photographers, men like Charlie Dawson, Andy Andrews, Herbie Ludford – all legends within their lifetimes in my eyes – and I never tired of asking questions and seeking advice. I was determined to join them one day, but to be honest I never thought I would make it.

For the next few years, time flew. My ambition was still that place on the grass at Leyton Orient, and to get there I saved up money from my meagre wages. I paid £4 for an old VN 9x12 plate camera and £20 for a Baldix folding roll film camera. These two cameras really changed my life. The plate camera, with its six single dark slides, produced images good enough for publication in the national papers. So it was that my first dream was accomplished – a pass for a Leyton Orient home match. I even produced an image that was published in the *Star*, one of Fleet Street's top evening papers. (An interesting note to all would-be press photographers out there: to operate the VN camera at a football match, once I pressed the shutter I needed a minimum of 30 seconds before I was ready to shoot my next exposure, so my timing had to be right! A modern digital camera can now produce 14 frames per second – progress indeed.)

The Baldix camera took my life in a different direction. I was able to photograph babies and weddings, and even a Bahmitzva (I lived in a very Jewish area). I was asked to take pictures of a very pretty girl at the church youth club we attended in Tower hamlets. I did a session with her and started a friendship that would lead to our marriage in 1960; we were both ridiculously young and naïve, but something worked for we are still married.

By 1961, I was getting publications in papers and magazines on a regular basis. This was the year my son Peter was born, and I knew that although my wage and publication fees would keep our heads above water, I wanted more for my fledgling family. I had to become a pro.

By working until she was 7 months pregnant, my wife received a government tax refund of £70, and we agreed to invest £40 of this in a Rolliecord VB. We couldn't afford a Rollieflex, but the superb lens on the Rolliecord took me into the next realm of press photography, and it was only a little slower to operate than its big brother the Flex.

Around this time I was told by Bill Hancock, our weekly salesman, that if I wanted regular publications, the three Catholic weekly newspapers were crying out for pictures, as they had no staff photographers. For a few months I followed Cardinal Godfrey as he opened churches and halls destroyed in the war, which gave me a regular income. In fact, I had my first "big" payday from getting into a service he held to "wed" two nuns to Christ (see page 8).

In 1963 I was given the freelance position for UPI at London Airport, starting my journey into the glamour of royalty, film and stage stars, and foreign assignments. My very first pro assignment was to meet and photograph Diana Ross and The Supremes as they flew into London. The pictures made all the evenings and two of the dailies – I had arrived! The position at London Airport also covered the film studios of West London where stars of the stature of Charlie Chaplin, Sophia Loren, and the Carry On team all worked. I was in 7th heaven.

My deal with UPI was that they would supply me with film and a retainer of £12 per week, I would give them exclusive use of my pictures, and they would syndicate them. All UK sales were totalled up at the end of each month, the £48 pound retainer deducted, and then the rest split 60/40 in my favour. For every picture they put out to the foreign press they would pay me £2 2s. It doesn't seem a lot now, but it allowed me to work as hard as I liked, and the harder I worked the more I earned. The pictures would always be my copyright, and I would be entitled to 60% of any sales. At the end of the sixties UPI and AP London started to sell contracts to the nationals, allowing any of the papers to use what they wanted with no further fees. I pointed out to UPI that this was probably illegal, and they allowed me a couple of days to get what negatives I could from the files, with the promise of further negatives if I needed any more. I unhappily agreed to this and removed what I could from memory; a few days later, when I was looking for more, I was greeted with the appalling sight of the London Bureau chief and the European Bureau chief cutting all the negatives in half and throwing them onto a skip. I still shudder at the thought of the history they destroyed that day, including my own images of The Supremes.

Over the next twenty years the national newspapers slowly shut down their library operations, and some of the images in this book reflect the damage this caused.

The Nuns' Story

It was 1962, and my main source of income, apart from my meagre Planet News Wages, came from regular cheques for pictures in the Catholic weekly newspapers *The Universe* and *The Catholic Herald*. I spent most weekends following Cardinal Godfrey all over London and the Home Counties as he opened churches, halls and hospitals that replaced those damaged or destroyed in the war.

I became quite friendly with a lady named Mary Quinn, private secretary to the Cardinal. She liked to see the pictures in the papers and after a few weeks was getting me in to the events as his personal photographer (not bad for a good East End Presbyterian!).

This particular week I called and she told me she was "so sorry" but the Cardinal was officiating in a private ceremony to "marry" two young nuns to Christ as they took their final vows. My heart skipped a beat when she told me the nuns would be in full white wedding outfits, and then change forever into their black robes, all in front of their friends and families. I imagined the incredible scenes that very few people had seen before, and the publication fees going begging. I pleaded with her but to no avail. She explained that the Mother Superior had the final say on who attended, the chapel was very small, and I would be in the way.

I decided on the "he who dares wins" approach. I searched the phone books until I found the convent in Greenwich; with trembling fingers I rang the number and asked to speak to the Mother Superior. I explained that I was the Cardinal's official photographer, and that although he would like me to attend, he could not authorise it. She reacted exactly as I hoped she would, "if the cardinal would like you to attend who are we to say no".

The only stipulations were that I could only work from a small side door to the chapel, and I could not use flash. I had two cameras to work with on the day: my Rolliecord and an old Reflex Korrelle, a pre-WWII single lens reflex with a

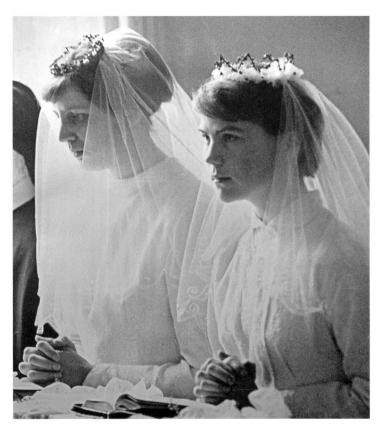

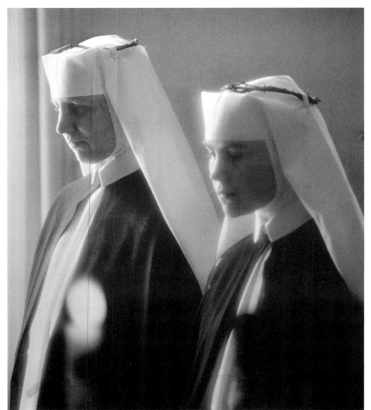

These are two of my favourite images from my whole career. I remember falling for the nearest and prettiest of the two; she had such a beautiful face. I wanted to rush over and beg her to think again about the massive step she was about to take.

Of course I couldn't, and the service ran its course as planned. Now, whenever I attend a wedding and the priest asks "if anybody knows of any reason…" I think of this scene. Reflex Korrelle with 8 inch F2.9 lens.

self-mounted 8-inch Pentac lens that had seen service with the RAF in the war. Working from my doorway, opposite the two 'brides' in their full white wedding outfit, the light streamed over them from two windows behind them. I bracketed several exposures, photographed the symbolic cutting of the first lock of hair by the cardinal, then waited with baited breath as they went off to change into their severe nuns' habits. My prayers were answered when they returned to the same spots, side by side; these images were magical.

Later, after the ceremony was all over I rushed back to Fleet Street very excited at what I had just witnessed, and sure I would earn a fortune from the Catholic and women's magazines. I left the negatives and captions for the weekly salesman the next morning, and went home a happy man.

At the end of the week, my happiness dissolved. Planet had issued two pictures abroad for which I was to receive four guineas, and the Catholic papers had only used one picture, a combined total of less than six pounds.

I felt very upset and frustrated as the rule was I could only sell my pictures through Planet News; again, he who dares wins! I hung about that evening and after all the managers had gone home, I printed off a set of large prints and the

story and left the parcel of both at the offices of *SHE* magazine, at that time the biggest of the women's magazines. A couple of days later I received a rejection, so I tried several more but with the same result. I tried *Women's Own* just off The Strand, and the next morning received a call to go in to them urgently. Bingo – I had scored.

I went into their office and was introduced to the editor and her make-up man and stood desperately trying to work out how much I would be able to ask for. They were planning a three page spread and the editor wanted me so sit with a reporter and talk through the events. She was very complimentary about the pictures and intended to use a lot of them: how much would I sell them for?

I got lost trying to work out how much I could ask for, then decided that as she had been very straight with me, I would return the compliment. I told her I would accept whatever fee she normally paid for such a spread. She thought for a moment then said "for a spread such as this I would expect to pay £100", but as she liked it so much, and I had been straight with her, "would I accept £125?"

I staggered out of their office, rang my wife and told her to prepare to celebrate. He who dared…had won.

Travelling Stars

In 1963, I started work at Heathrow, the week John F Kennedy was assassinated. These were the early days of The Beatles and swinging London, and I couldn't get enough of the glamour and excitement raised whenever pop groups went through. I told the VIP minders I would do any group at any time, and this brash promise dropped me in it a few weeks later.

The BEA VIP came into the press room to tell me he had a group flying up to the north of England. I went out onto the balcony overlooking the concourse and watched a group of long haired young men wandering about, with no one taking any notice. I asked who they were and the minder said he thought they were Manfred Mann and his group. I told him I would meet them airside, grabbed my Rollie and went to photograph them. I took some group shots on the aircraft steps, then asked them to line up so that I could get a caption shot (names left to right). I took the picture, then pen in hand went up to the leader and said "If you are Manfred Mann,

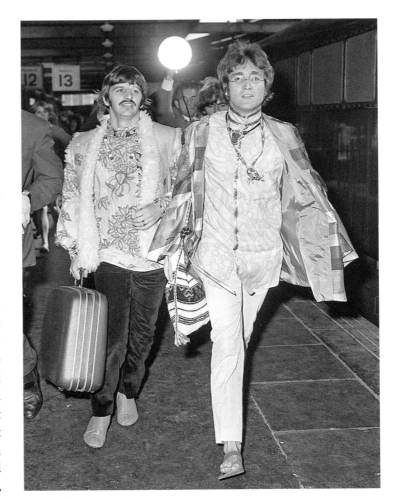

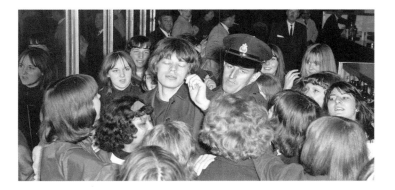

Bands on the move. John Lennon leads Ringo Starr, both dressed in Eastern outfits, to the train to take the whole group on a mystical weekend retreat with the Maharishi. Mick Jagger is mobbed at Heathrow, and The Stones leave Heathrow Airport (not the Manfred Mann group). Nikon F1s.

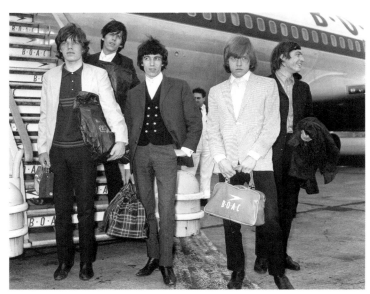

what are the rest of the names?" There was a short pause then he said rather indignantly, "I'm Mick Jagger, and we are The Rolling Stones". On that day I had never heard of them, but at least they gave me their names!

Within a few weeks The Stones were almost as big as The Beatles. Whenever big name groups like these were travelling, they had PRO (public relations) firms letting the fans know where and when, so it was almost impossible for them to slip through without being mobbed. The airport police provided protection where they could, but screaming, determined teenage girls can and did get anywhere. When the groups left on big tours they would wave from the tarmac to the fans in the viewing galleries. But this was never enough for the hard-core fans who wanted to get close. Gentlemen, your life is in your own hands!

The Beatles were heading to Wales for a spiritual weekend with the maharishi. Any normal group off to the country would be a difficult trip to organise, particularly if they turned up late for their train. The Beatles, with their road managers, wives and girlfriends, were no exception.

They arrived at the station in separate cars, all dressed in eastern style shirts and coats, and covered in sheepskin and beads. John Lennon lead the group from the front with the rest trailing behind him. His wife Cynthia was so far behind she ended up missing the train, despite the best efforts of Patti Boyd and her sister.

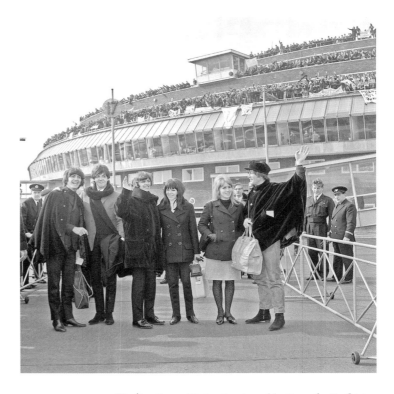

The Beatles and their wives leave Heathrow for the States. The fans were as enthusiastic as ever, and crowded all over the viewing galleries on top of the terminal buildings. This is George Harrison in his "Pickwick" hat and glasses, with a close up of the screaming fans on the rooftop. Nikon F1s, various lenses.

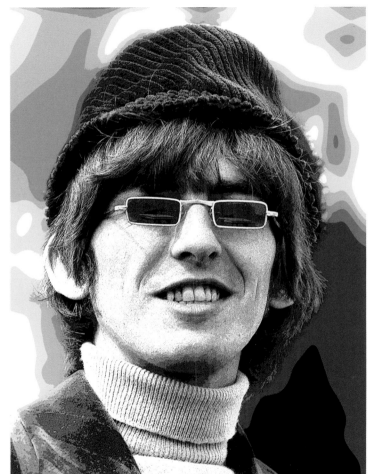

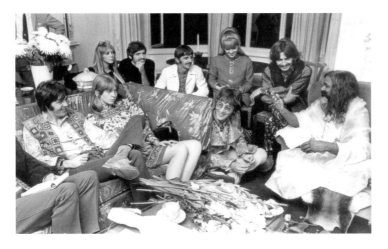

The Beatles and entourage gather at the feet of the Maharishi. Nikon F1 3,5mm

The maharishi arrived separately and was ushered through the press pack and onto the train.

The Beatles were now the number one group in the world. On this particular occasion George Harrison, normally one of the quieter members of the group, turned up in a "Dickensian" outfit of a striped blazer in two strong colours and a Pickwick hat. I had just bought the Mamiya C2 camera with a 180mm lens, and I was able to fill the frame with his hat, head and square glasses. The next day this image was in several of the dailies, and within a week all of the staff men had the camera and long lens. Not something they thanked me for, because it was very heavy and cumbersome, but the quality of that lens was something else.

Heathrow glamour in the 60s

Brigitte Bardot at London Heathrow Airport 1964

She was every man's dream, the sexy French film star who had taken the world by storm. She arrived at the airport wearing a figure hugging sweater, a tartan mini skirt and bare legs, and sandals. Her golden hair flowed in the wind, and she had an ever present smile as she walked through the crowds of admirers.

She made up her face with a mirror with a face on the reverse that made great pictures, and she moved like a sleek cat as she was filmed, running through the airside channels, and posing on well-lit passenger stairways.

It was very easy to see why she was a star, and like the other people around the set I was smitten with this Gallic imp. It was not until later that I learned that this 'teenage' sex-bomb was in fact 30 years old that year.

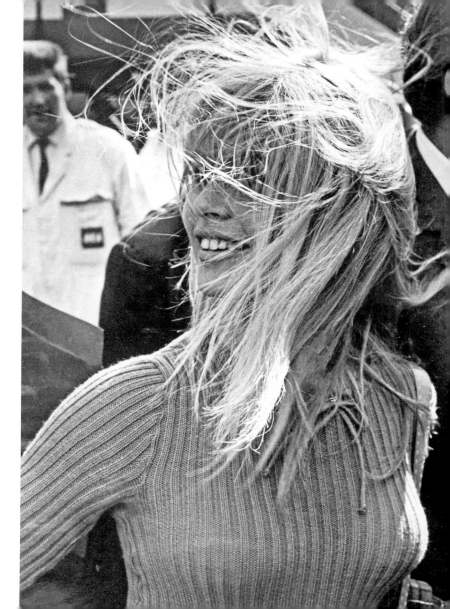

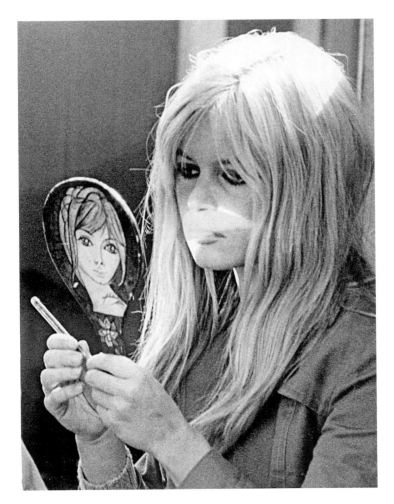

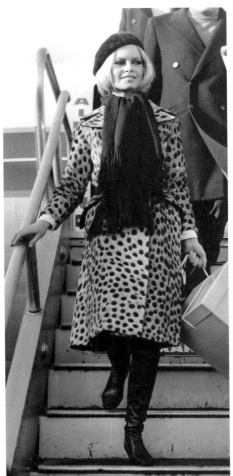

Brigitte Bardot adjusts her makeup with a very girly mirror. The last shot, taken later, shows her arriving in a fur coat; I never could decide if it was real or fake. Nikon F1s.

[Opposite page] The incredibly beautiful Sophia Loren sitting on a camera dolly at Pinewood, watching Chaplin working on a ballroom scene from Countess from Hong Kong. I didn't pose her for this shot; in fact, after I had shot two exposures, she swept back to her dressing room! I have always loved this image.

One of my great pleasures during the airport years were my trips to Pinewood Studios, which was about 5 miles from the airport. I soon knew all the PROs for the various film companies and spent many happy hours shooting glamour and film stills. On this particular day the whole of Fleet Street had been invited onto a set where the immortal Charlie Chaplin was directing a film called "Countess from Hong Kong", starring among others the beautiful Sophia Loren.

Mid way through the morning, Chaplin was directing a scene on a dance floor filled with couples, about sixty people in all, when I noticed at the back of the set Sophia Loren sitting completely unnoticed on a camera dolly as the crew prepared for the next scene. She was dressed in a sensational white gown, very low cut, and looked a million dollars as she gazed across at the filming. I managed to get off two exposures before she saw me, stood up and flounced off to her dressing room, obviously upset at being ignored by Chaplin.

The picture is still one of my favourites of this era, and although she and Chaplin were the best of friends later at his on-set birthday party, I think when I shot the picture she could have happily strangled him.

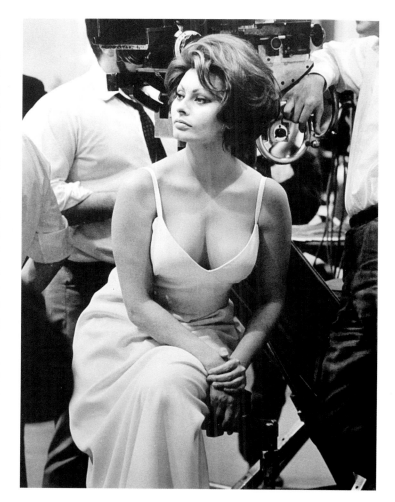

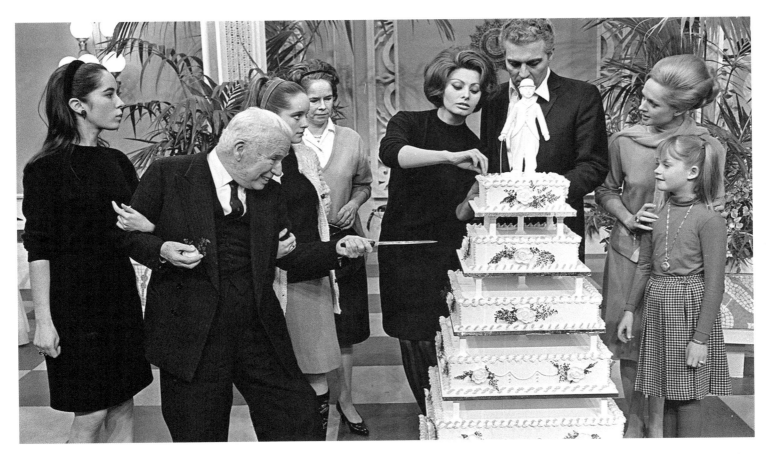

The unforgettable Charlie Chaplin cuts his birthday cake on the set of Countess from Hong Kong, surrounded by family and stars of the film. Nikon F1 3.5mm lens.

So many stars were launched in the excitement of the "Swinging Sixties", and this young lady was one of them. Twiggy was discovered and launched by her fashionable manager Justin De Villeneuve, born Nigel Davies, in Edmonton, North London.

This was one of the first times I photographed her as she flew out to the States. With her huge eyes heavily made up and her hooded costume I felt she looked like a sexy nun, if that were possible. It was easy to see that she had a different quality, and she went on to become a superstar.

I met her many years later in her dressing room in a Broadway theatre where she was starring in a musical. I had gone in with Jean Dobson who had known her as a teenage model when Jean was the *Daily Mirror* fashion editor. I was struck with the difference 20 years had made as the gawky young model had become an extremely talented musical star.

The second outfit she is wearing on the steps of the plane really needed colour film, as it was a sensational mix of orange and light blue, but we hadn't reached the colour period.

Throughout my years at Heathrow all the stars, both men and women, wore furs, stunning outfits in red fox, silver fox, leopard skin, ocelot, and mink in all of its shades. At that time it was a symbol of wealth, and I had no problem with it. I just enjoyed photographing the stars wearing them, and the glamorous images they created. After a huge spread in *The Mail* one of the top London furriers let me buy a coat for my wife

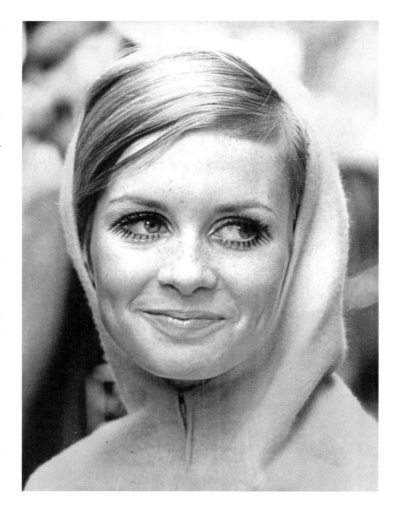

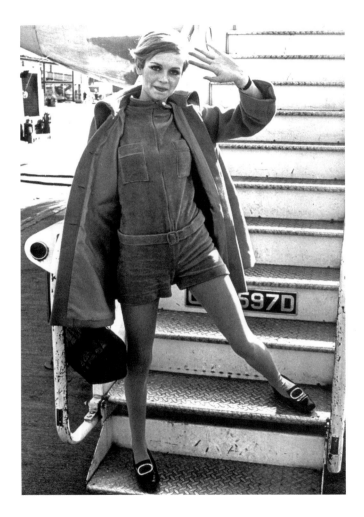

at trade price; it was a beautiful red fox jacket and she loved it. But come the Eighties it was suddenly politically incorrect; any woman wearing real fur could be attacked on the street, or have paint thrown over her clothes by the "loonie" left.

I got into a furious row with a senior fashion writer from one of Fleet Street's top papers over this issue. I allowed her to preach at me for several minutes about cruelty to animals, and when she finished I asked her why she was wearing a fashionable leather belt. She tried to explain to me the difference between an exotic animal killed for its fur, and a domestic animal killed for meat and leather. I explained that whatever she thought, both animals finished up dead! She never spoke to me again, I am very pleased to say.

I still am unsure as to how many of these coats are real fur, or just clever fakes. In the case of Bardot and her love of animals and later work for them, could she be wearing real leopard skin? I leave that to you to guess. For the royal family on the other hand it was quite proper to wear beautiful mink coats, and they did so with no hint of the troubles to come (although they don't wear them now!).

Twiggy exploded onto the scene at the start of the "Swinging Sixties". You can see from the portrait that she was a bit special, and as thin and small as she was, she could wear a dress. Nikon F1s, various lenses.

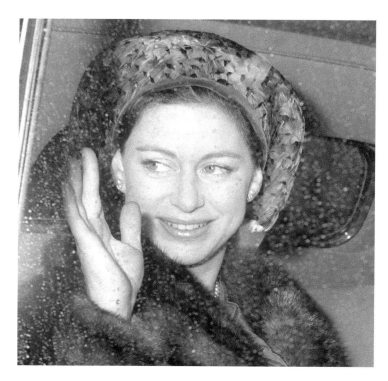

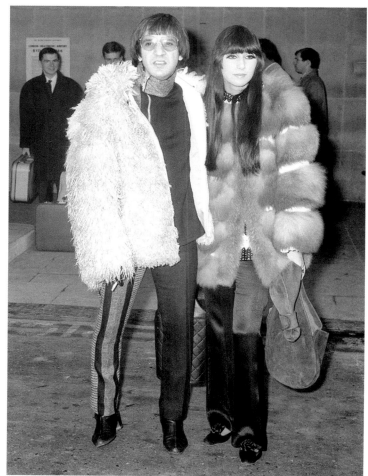

Princess Margaret and Sonny and Cher parading their fabulous
fur coats at Heathrow, in the days when it was still safe to wear
them. By the Seventies and Eighties the "Loonie Left" had made
it impossible to wear such fashions on the streets anywhere.

Royals

Whenever any members of the royal family used the airport they had a special suite on the north side, where we were allowed to shoot pictures from behind barriers, usually seven or so yards from the subjects. This was fine when shooting full length pictures, but when Princess Margaret went into her "hat" fashions, the distance was quite frustrating.

This was one of the reasons I swapped at this time to the Mamiya C2 camera with its magnificent 180mm long lens. If you compare the images of the princess in her hats, the dark feathered creation is so much better in quality. This was also the lens I captured the portrait of George Harrison with, leading to all airport photographers getting the camera.

The picture of Prince Charles and his father, Prince Phillip, was a happy accident as they walked out to their plane together. Charles really was a "chip off the old block", which several papers used and commented on.

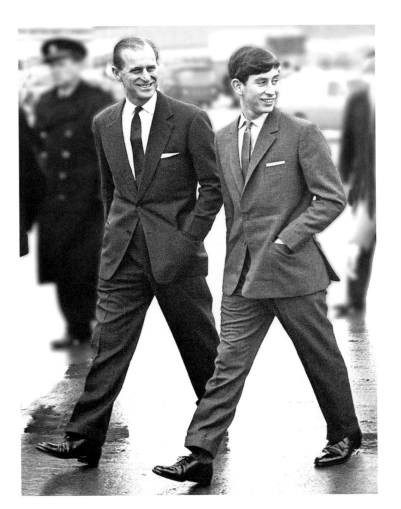

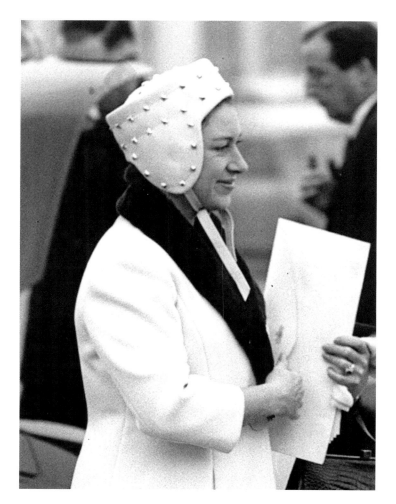

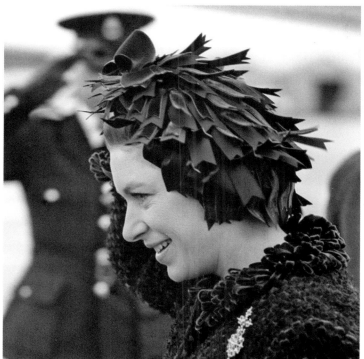

Princess Margaret in her "mad hat" period; this phase was the reason I bought the Mamiya C2 camera with its 180mm Tele lens. In the first picture she wears a medieval helmet style hat; the picture is a huge pullup from a negative shot from seven yards. The second feathered creation was shot on the Mamiya C2 with 180mm lens; look at the difference in quality and detail.

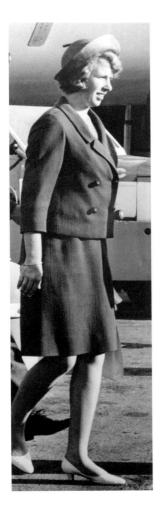

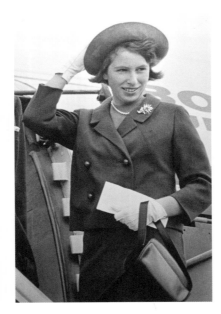

Princess Anne at this stage of her life was a rather awkward looking teenager. Obviously heavily influenced by her family, she wore none of the outrageous fashions that the teenage girls of the 60s were adopting. She looked like a younger version of her mother or aunt, without the fashionable hats.

Princess Anne holds onto her hat as she flies out in a rather dowdy outfit, just like her mother's.

Chinese street riots

In 1967, my big mouth got me into trouble again. I had a run-in with the picture editor of Planet News on a day when nothing much was happening. I complained at the lack of work, so he ordered me to the Chinese embassy, just around the corner from the BBC in Portland Place. For some weeks this had seen various incidents, as the young Chinese staff handed out *The Little Red Book* of Chairman Mao.

I had managed to avoid "doorstepping" the embassy, but now my goose was cooked. I was feeling sorry for myself as I strolled up Portland Place. I stopped to ask a traffic warden where the embassy was; he said, "keep walking about 200 yards, they're all fighting outside."

I must have broken the world 200yd record as I sprinted up the place, and sure enough, there was a huge Irishman fighting a small, younger Chinese man. In the background the police were calling for backup, and a group of Chinese men were arguing with the Chief Inspector. Apparently the

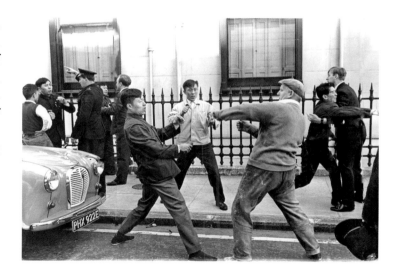

This picture shows the large Irish labourer taking on two little Chinese men as their colleagues argue with the police inspector in charge.

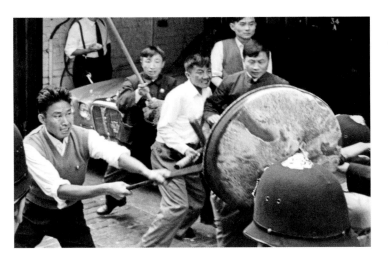
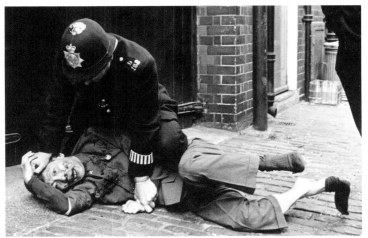
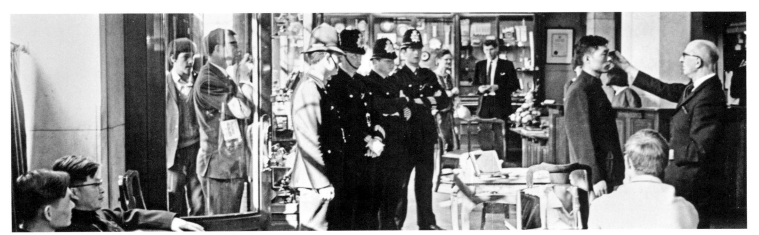

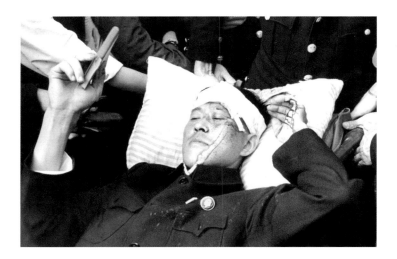

[Above] It might be stretcher time, but The Little Red Book of Chairman Mao is still brandished proudly.

[Opposite, clockwise from left] A PC uses a dustbin lid as a shield and a shoeless Chinese man is punched to the ground. The next day in the opticians with a strong police escort, the injured Chinese men have their glasses repaired

young Chinese man had thrust a copy of the *Quotations from Chairman Mao Zedong* into the hands of one of the Irish navvies walking past the embassy. The Irishman had torn the book in two then set about them. These guys were no Bruce Lee, and one by one he flattened them until the police managed to stop him.

I filled my boots with pictures, and phoned the office for a dispatch rider to collect my film. The DR arrived with my mate and senior photographer John Wilds, who gave me bad news. While he was to watch the front door, I was to go round the back, some 400 yards into a mews to watch the back door. This was the picture editor's revenge!

I walked quickly round the back with two other photographers and found a police car already there, then all hell let loose! A bunch of about eight Chinese men, armed with baseball-type bats, ran out of the back door and piled into the police. The police drew truncheons and grabbed dustbin lids and fought back hard, and in the flats above, people threw milk bottles at the Chinese.

It lasted just a few minutes. Someone shouted they had seen a gun; the police backed off, and the Chinese carried their injured into the embassy. As the door shut, up ran John Wilds and the rest of the pack. John ordered me to the front door as he and the other 'number ones' waited at the scene of the battle. I protested, but being the junior photographer, I had to do as I was told.

I walked to the front door and right on cue, the doors opened. Out came the injured on stretchers, all still carrying *The Little Red Book*. Great pictures.

The next day I had 43 major pictures in the London dailies (a good hit was normally 3 or 4) and I had scooped the entire world's agencies. Poor John Wilds had been with me through the incidents but never took a single picture – somebody up there loved me!

With two senior photographers I was to return to the embassy the next day to try to repeat the performance. I was ordered to stay by the front door with one of the senior photographers, while the other senior man made his way to the back.

About mid-morning the front doors opened, and out walked a small group of Chinese staff all wearing their MAO badges, clutching their Little Red Books, and proceeded to walk up the road towards Regent's Park. A couple more of the Chinese brought out a loudspeaker and started to complain of police brutality the day before. I was ordered to follow the walking Chinese who were being followed by a small line of coppers. I was not happy with this as the front of the embassy looked the likeliest place for pictures, but orders were orders so off I walked with about six other photographers.

The group walked for about half a mile with their police escort, and one by one the photographers dropped off back to the embassy. We believed the group were simply getting a breath of fresh air. When we came to a large opticians on a street corner, the Chinese all filed into the shop, followed by the police escort. The police formed a line across the shop and watched as the Chinese had their eyes tested for new glasses to replace those broken in the fighting, all of this taking place in complete silence. Of the three photographers left, I was the only agency man. The guy from *The Mirror* had pushed the door open a few inches and was snapping away; I decided to go round the corner to where a door gave a different aspect to the scene. I pushed the door open enough to accommodate my lens and started happily clicking away.

Once again by following orders, I had my pictures in every national, including *The Mirror*. UPI once again smashed our rivals Associated Press all round the world (as it had done with my embassy pictures the day before), and I wondered how long it could last.

Here is a lesson for any would be news photographers reading this: even if you have the most expensive equipment in the world, if you are not in the right spot, facing the right way, you will get nothing!

The Shah's Coronation

I still recall the excitement as I walked round UPI to the European editor's office to be told officially that I was to be part of a four-man team covering the coronation of the Shah of Iran, the reward for my exploits at the Chinese embassy. The other photographers were coming from the States and Germany. My first foreign assignment.

I travelled out with the London Bureau chief, Jim Spencer, who was in overall command of the coverage. He, along with the rest of the London staff, didn't think I should be there. We were given four positions for the coronation, and I was assigned to the palace garden where the coronation party of the Shah, Empress Farah Diba and the Crown Prince would all process in full coronation regalia after the ceremony.

I sat behind a small table with my equipment laid out on top, which comprised two Nikons with long lenses, a Nikon with a 35mm lens for a wide shot, and a spare body just in

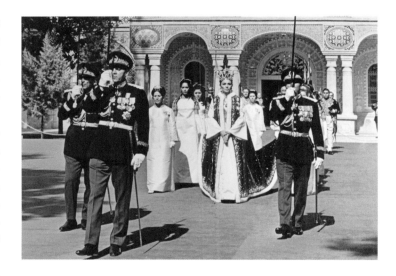

The Empress Farah Dibah with escorts and ladies in waiting process through the Teheran palace gardens. Rollieflex.

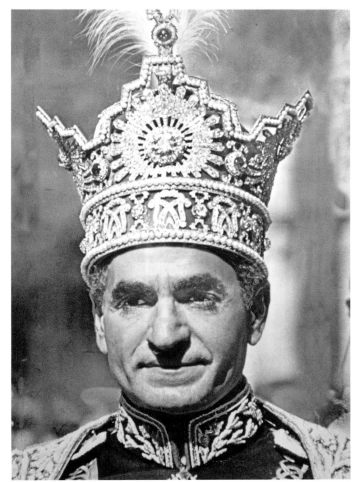 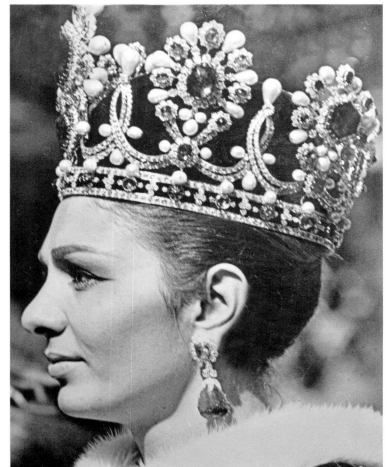

case. I was asked to shoot a general view on two Rollieflex, one colour and one black and white, as the Shah walked past. Then I was to switch to a Nikon with a 300mm lens for a close-up of his head and crown in black and white and then switch the lens to another body loaded with colour. As soon as he was past me, I had to repeat the efforts for the Empress, then again for the Crown Prince. At the last minute Jim Spencer produced a 5×4 speed graphic with a polaroid back that would give us an instant print of the Shah walking past that could be wired without processing time. I protested and requested a second pair of arms be fixed to my body, but was sent packing with "they won't be moving fast so get on with it", and the editor's old advice: "you'll manage".

I did manage, somehow. I would like to say it was an easy task, but I would be lying. I got through the routine for the Shah, but almost dropped the 300mm lens as the Empress processed past. I got the GV (general view) off on the Rollieflex but was late on the head shot, hence the side view of her crowned head. This turned out to be another happy accident for this shot was published all round the world.

It had been arranged for me to leave by a back garden door in the palace walls, where a taxi waited to take the 5x4 to the office, and another taxi would take me straight to the airport to catch a flight to London – because of the time difference, I would arrive back in London for the originals to be issued. Goodbye all the free trips around Iran the Shah had laid on.

I remember arriving back, rushing through customs and giving all the film to a dispatch rider, then standing knackered, surrounded by my cases of equipment and clothes, working out the best way to get back to the office. They had economised and not sent any transport for me. A hard lesson learned!

I was saddened to see him deposed in 1979, and even sadder when he died, probably of a broken heart, in 1980.

(Far left) The Shah in the imperial crown processes through the palace gardens. Nikon F1 300mm lens

(Left) The Empress follows the Shah through the palace grounds. In swapping cameras I missed the head on shot, but this one was received round the world because it showed the magnificent earrings she wore with the crown. Nikon F1 300mm lens

Introduction – The 70s

By the end of the 60s the great Rollie era was ending. This medium format camera had been the mainstay of Fleet Street for over 10 years, as it had replaced the speed graphic era of glass plates and slides.

Now in turn the Rollie had to give way to the 35mm cameras, first the Pentax Spotmatic and Leica, then in swept Nikon and Canon to smother the street. In 1969 I was working a pair of Nikons, and these remained my main tools until the dreaded digital revolution of the late 90s.

Roger Moore marries Luisa Mattioli, Caxton Hall, April 1969

I always had a soft spot for Roger Moore and Luisa Mattioli as they often passed through Heathrow. He was unfailingly polite and obviously valued good press coverage; he couldn't get a divorce from Dorothy Squires, so he and Luisa lived together.

When he finally got his divorce and married Luisa at Caxton Hall in London, I volunteered to cover the wedding. It was quite a bunfight! This was the era when 35mm drove medium format off the street. As you can see in the picture one of my old friends George Stevens of Press Association, just to the right of Roger, is getting a good elbowing as he attempts to get a yard or two back from the bride and groom. I remember it well.

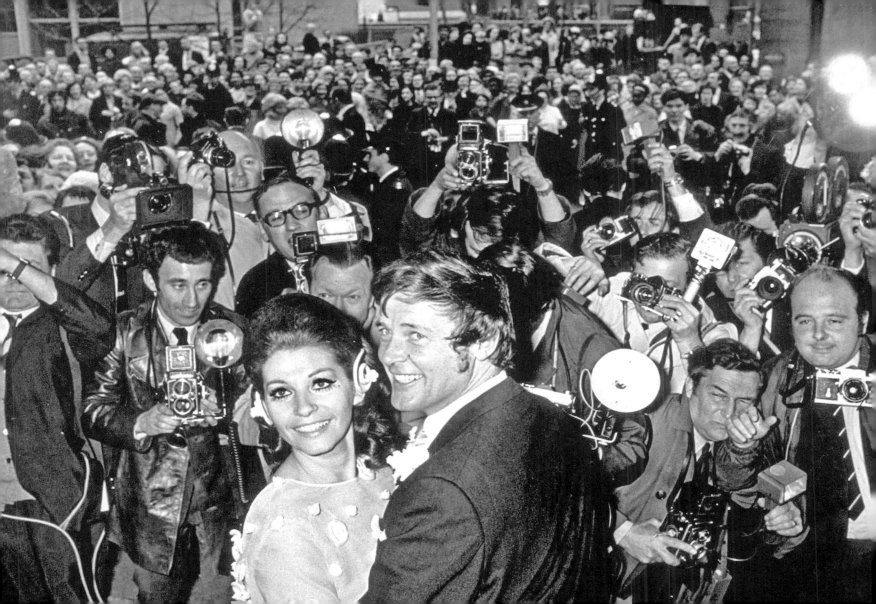

Roger Moore's wedding

This picture, taken in 1969 on a Nikon F1 with a wide angle lens, of Roger Moore marrying Luisa Mattiolli at Caxton Hall in London, illustrates perfectly this change in equipment. Roger Moore had been with Luisa for some years; he was married to the singing star Dorothy Squires, who refused to divorce him. When she finally did, his marriage to Luisa was a big story, hence the number of press photographers. A lot of my old friends are in this picture; the 35mm boys are finding it easier to work in the cramped conditions!

I was given a staff job with the *Daily Mail* in October 1969. This was the old broadsheet, and I didn't know the writing was on the wall for this failing newspaper. *The Mirror* and *The Express* dominated the street, but I was happy for a few months – I was made chief sport photographer, and I covered my beloved sport all day long. It didn't last. In early 1971 I, along with all the rest of the staff of the *Mail*, was made redundant, so that David English and the "Sketch" team could launch the first serious tabloid newspaper in the UK. The new tabloid *Daily Mail* under English's brilliant direction was designed to get behind the main news stories of the day and tackle them in depth. I was offered a freelance contract, and with three children and a mortgage, I accepted it with open arms.

This was to be one of the most productive decades of my story, although it was also one of the shortest. In 1974 I was persuaded to accept the position of "night picture editor". I ran the desk each evening for four years, and hated every minute of it. The politics and silly games played by other 'mini execs' trying to score cheap points with the editor, which he encouraged, were not for me. I came to an agreement with the editor that when a staff job became available, I could go back to photography. It took four years!

By this time I had discarded all of my medium format cameras and was shooting on two Nikon bodies with various lenses. I carried lenses from 300mm to 21mm with me at all times and if I needed anything longer or wider, then we had a communal cupboard to share.

TVR nude models

Since I was freelance, I was able to shoot pics for Rex Features, one of Fleet Street's leading agencies. Their main interests were features and glamour, as they still are.

TVR announced that in 1971 in the long-running war of the prettiest and least-dressed models at the car show, their models would pose completely naked. This caused a great deal of anxiety for the new tabloid *Mail*: they could not ignore one of the big stories of the day, but they did not want to be compared with the "red tops" that showed topless models every day.

None of the staff photographers wanted the assignment as they had been warned off all sexy images. I volunteered to go as I could shoot images for Rex (and I wanted a close up of the cars!). I wrote off any chance of a pic in the *Mail* and so I concentrated on the girls and cars. As the girls stripped off their light coats and draped themselves on the cars, all hell broke loose. It was the scrum to end all scrums, elbows and fists flew, oaths were screamed and it took the police to restore order by telling the girls to dress and go behind the stand.

Several photographers arrived late and completely missed the action; they berated the TVR manager of the stand for a repeat. He thought about it and decided to give it a go, but told them to depart and return in 30 minutes.

I had all the shots I needed, so I looked around and wandered up to a first floor balcony that overlooked the TVR stand from the back. 30 minutes later, the girls repeated their first showing, and on a 135mm lens I got a great picture of naked backs and snarling press. On the LADA Russian stand behind TVR a group of women took over, carrying banners protesting at the Russian expatriation of Jewish refugees to Israel. No one blinked an eye as the press carried on with the TVR girls, until eventually the police broke it up. I was left with an image the new *Daily Mail* could use all over page three, showing two naked women without offending their mostly women readership or middle management. This propelled me from the top of a heap of also rans to a trusted photographer with large, expensive assignments. A great start to a new decade, plus a large cheque in the bank!

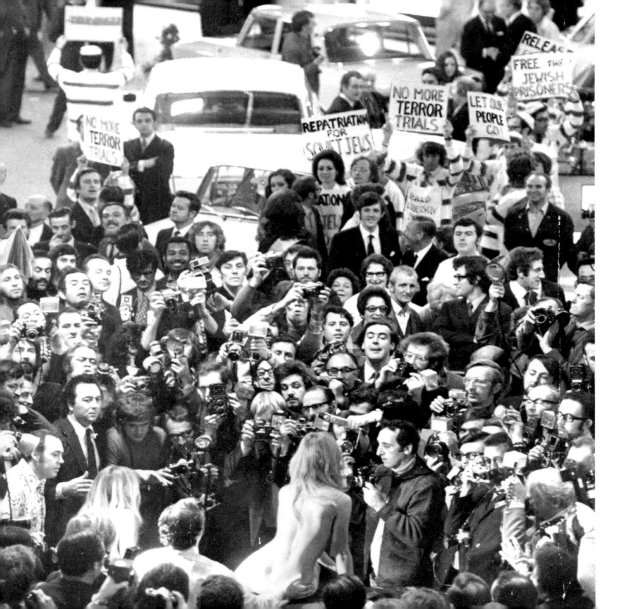

[Left] In 1971 I was freelancing for the Daily Mail, having lost my staff job when the Sketch swept in and turned the paper into the first news tabloid in the UK. Here at the start of the second "showing" by the nudes I got my exclusive. After the event, the girls tried to claim that they had been stripped of their undies by the photographers pack, but this picture nails the lie.

[Opposite] Early in the 70s I travelled with our Defence Correspondent to cover an exclusive tip he had been given that the army were training women soldiers with guns. I was terrified that one of them might have reloaded her weapon after I had checked they were empty. I took the "charge" picture on a telephoto lens to foreshorten the image, and in the freezing conditions my eyes would not stop streaming. The beautiful captain in charge agreed to level her automatic pistol at me, and I had it. When the Mail published the pictures all hell let loose from the Ministry of Defence and our Fleet St rivals.

Women soldiers

I travelled to Germany on an exclusive tip to our defence correspondent that women soldiers were being trained in the use of weapons, something the women's lib movement had been calling for to show that the women were as good as the men. I flew out with Harvey Elliott to a practice range in the British sector, and sure enough, in the middle of a blizzard a group of female soldiers armed with light machine guns were being put through their paces, all under the control of a very attractive female captain. In overall command were two staff officers who allowed us to photograph the group posed at the end of the range.

After about half an hour of very correct pictures, they left for the officer's mess and that was when I struck. I told the women they looked like they were "posing", and they wouldn't scare the pants off a scarecrow, let alone an enemy soldier. They didn't need too much encouragement to stage a "charge" at me through the heavily falling snow, and the captain even aimed her pistol at the camera for me. (I did personally make sure all the guns were empty, you can't be too careful!)

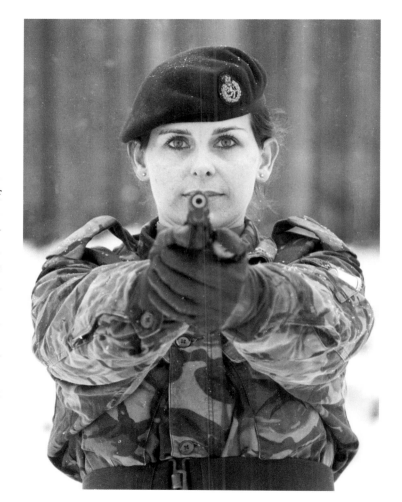

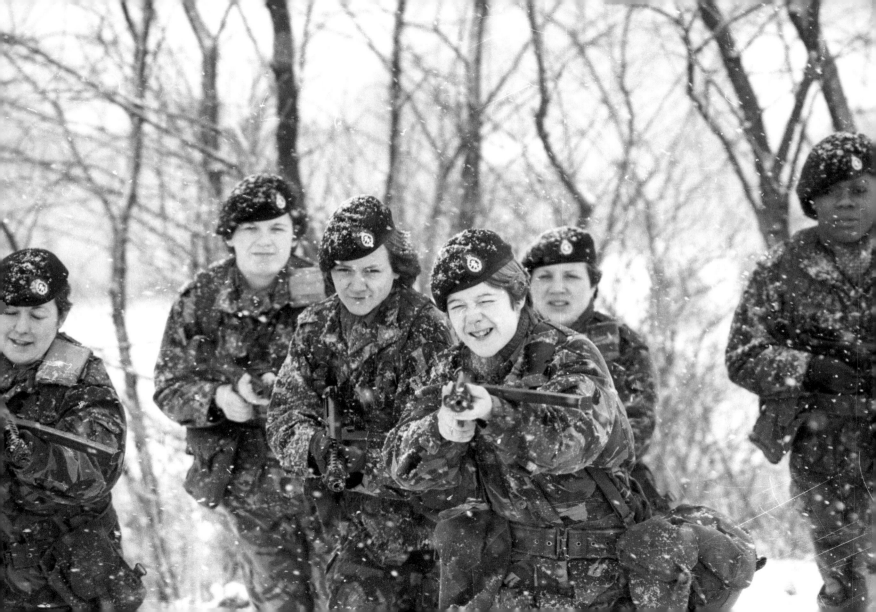

Enoch Powell

I was on my way out of the office one evening when I was called back by the picture editor and handed an interview Linda Lee Potter had held with one of my heroes, Enoch Powell. In my opinion, he was the greatest Prime Minister this country never had, a political giant who dared to voice concerns over the country's rising immigration figures.

His famous speech at Wolverhampton had destroyed his career, when he forecast "blood in the gutters", and a foreign religion holding power in this country. Time has proven him

When sitting in with big name reporters, I observed the way they messed around with their subject and saved the "main" question until last. Here with Enoch Powell I played the same game, spending several hours chatting with him and shooting pictures, only asking for this picture as we were finishing; when he agreed I turned cartwheels in my mind.

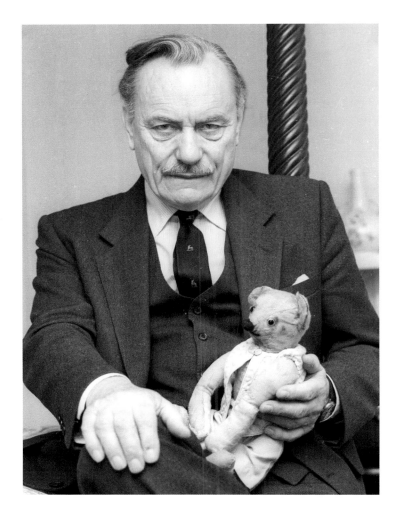

right with his warnings, but in those days he was vilified and thrown out of the Conservative Party.

He had just joined the Ulster Unionist Party when he gave the interview. I was told to report to his Westminster house the next morning, where he had agreed to an hour's photographic session. My hero greeted me in an immaculate three piece suit and tie. He made the tea as we chatted, mostly about my early life in the East End of London. He allowed me to photograph him in his study where the walls were decorated with political cartoons of his career, a lot of them far from flattering. After about two hours of talking and photographing, he decided he had to get back to the Houses of Parliament. He asked the normal question used at the end of all such sessions, "Did I have everything I wanted?" I was nervous. I had enough pics for a spread if

he said no, but I asked "Could I photograph you with your teddy bear?" He stopped, looked at me quizzically and asked "How do you know about him?"

I told him Linda had mentioned it in her interview. He then wanted to know what purpose this picture would serve and I enthused that "as he was seen as a devil by the left-wingers, this would illustrate his human side".

He thought for a while, then led me to the master bedroom, where in the middle of a barley twist four-poster bed sat his battered childhood teddy bear. He sat on the side of the bed and cradled his lifelong friend as I clicked away. Once I had what I wanted, I braced the camera and asked innocently "Could you put him up to your cheek?" He glared his refusal. I clicked and I had this image – it was used as a centre spread.

Keith Castle

Linda Lee Potter also accompanied me on another great adventure: photographing the UK's first heart transplant patient at Papworth Hospital. *The Mail* had paid a fortune for the exclusive, which the hospital was against, but we were reluctantly granted one hour in a room full of rarefied air.

Keith Castle was a lovely man from Fulham and we had a happy interview, interrupted only by a disembodied voice

This is Keith Castle performing his first knee bend for me in Papworth. We were working in his room with the rarefied air; the hospital executives were listening in to all our conversations, and I felt very intimidated. I have never felt as scared as when Keith insisted in doing six, the second six that day; he was labouring and breathing heavily. I deliberately asked him to stop in a very loud voice, hoping the medical staff would intervene, but nobody came to my rescue. I think that was the day my grey hairs started!

from the next room. I photographed Keith painting and laughing, but we were ordered to stay in the one main room, which when you are trying to get some variety into your images makes the situation very difficult. Keith, God bless him, pointed two fingers at the wall from which our orders came, and said "I can do my exercises here". Apart from some gentle stretching, his proudest piece was to hold the wall with one hand, slowly bend his knees to a crouch position, and then come back to upright; he told us his daily quota was six of these.

He had already done his quota that morning. I asked if he could manage two more for me so I could get one colour and one black and white image, and I can still see his face when he said "I can do six!" He held the wall and slowly sank down, smiling at the camera as he went. As he came up I swapped to the other camera for some colour shots. Slowly, he went down again, then slowly up. As I thanked him for the efforts he started down again. I protested that he had done enough, but he insisted he could and would do six. I placed both my cameras on the floor to show his efforts were unnecessary. I couldn't touch him, and both he and I were beginning to sweat.

I prayed that the voice next door would intervene and stop him, but there was just silence in the room as he slowly and surely completed six, meaning he had done 12 in a day! Behind her mask Linda was looking very concerned. She spoke to him and asked him how he felt; he assured her he was fine. He just sat in his armchair sweating lightly. At that moment the voice boomed out that our session was over and would we kindly leave the building. We needed no prompting. In the car we were both laughing and fretting at how it had gone. I had the driver tune the radio in to BBC1 to listen for any news of the sudden demise of the first heart transplant patient. Thankfully, it never came, but I am sure I aged a few years in those fraught minutes!

Keith Castle with his granddaughter. It proved difficult to light candles due to the rarefied air in his room!

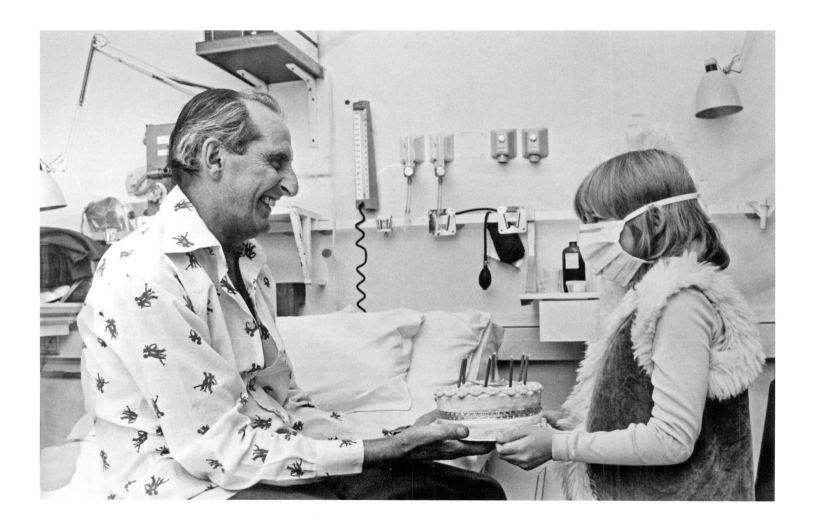

Mick Jagger

I had been covering a test match at The Oval, but for some reason I needed to finish early to get home. I bundled up my heavy tripod, camera cases and long lenses, and with both arms full I staggered towards the members' gate. As I stumbled through who should stroll into the ground past me but Mick Jagger, a keen cricket fan, and his new wife Bianca. I couldn't take a picture as all my cameras were packed away, so giving the doorman a bung I stowed all my gear in his hut, grabbed a body and an 80/200 zoom and followed. Photographers were not allowed in the Mound Stand, so another financial passport was needed to allow me to creep down the aisle on my knees to where I could see Mick and Bianca sitting mid row. I clicked away for a few seconds, and then couldn't believe my luck as Mick let out an enormous yawn! The steward was now pulling at my leg and whispering it was time to go. As I went to get up, Bianca matched Mick's yawn with one of her own. I had an exclusive front page display that excited the editor and made me very happy. I would like to think it was only the cricket they were bored with, since they were just married!

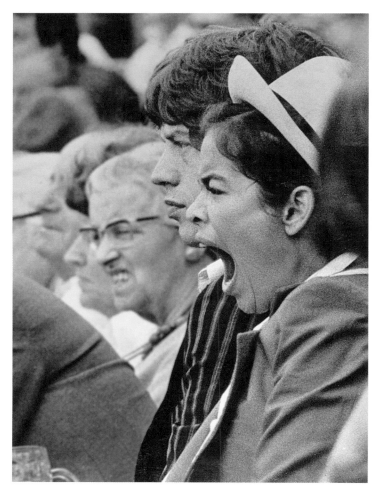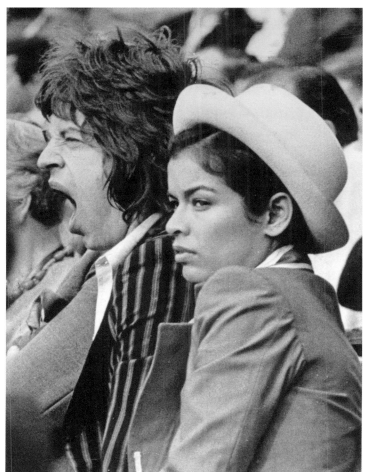

Royal wedding

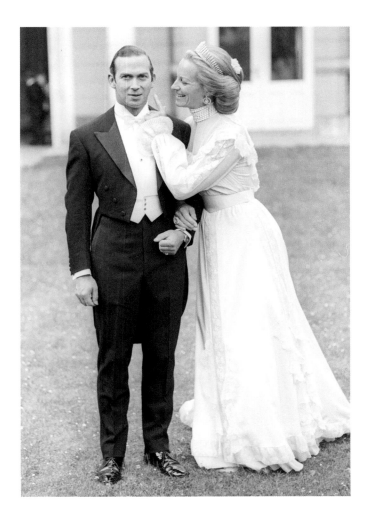

In 1978 I was sent to Vienna with several other Fleet Street photographers to cover the wedding of the Duke of Kent to the Baroness Marie-Christine von Reibnitz, a divorced Roman Catholic. Because of the divorce, the wedding was held in Vienna at the Town Hall; Lord Mountbatten and Princess Anne were the representatives for the royal family.

On the morning of the wedding we all waited in a small courtyard across from the Town Hall for the wedding party to come out and pose in a small informal group. There were two shots to be done here, a 35mm shot of the group, and a 135 mm close up of the bride and groom in the centre. As we all tired of the group shot and changed cameras for the close up, the princess instinctively kissed the prince on the cheek; something the royal family never did in public.

I, along with a few others, had the image, but the majority of the press had missed it, and no amount of pleading could get her to repeat the performance.

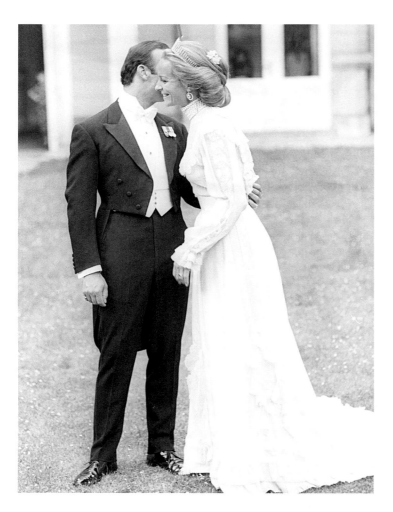

We all went back to the city agency office and wired to London, before returning in the early evening to photograph the bride and groom at their formal wedding supper in the Embassy. We waited in the garden and slowly the couple walked across the lawn to meet us.

She looked magnificent; she was a tall, stately woman anyway, but in a full-length flowing dress, and wearing Queen Mary's old jewels that the Queen had lent her for the occasion, she was stunning.

We shot loads of pics of them standing there, then the cry went up "give her a kiss", most vehemently from the photographers who had missed the morning kiss. He stood there stunned and embarrassed, not knowing how to handle the situation. She obviously liked the idea and started to chide him with "why won't you kiss me?" and flirted with him outrageously, touching him under the chin and smiling at him beautifully. Eventually, he quickly kissed her on the cheek, with his lips hidden by her head, but it was still a kiss.

This was the happiest set of pictures of royalty I ever took. The royals had entered a new era that would lead to Charles and Diana kissing on the Buckingham Palace balcony, and Andrew and Fergie in the palace garden.

Sean Connery in East Berlin

Ian Fleming himself would have had trouble dreaming up my assignment with Sean Connery in the old communist capital of East Berlin. Connery had starred and invested in a film called *The Offence*, his first role away from the James Bond character that had made him a world star.

He was about to tour West Germany, where the film was to have premiers in Cologne, Hamburg, Berlin and Munich. *The Daily Mail* had a deal with the film company to cover all of these, and in return Sean would enter East Berlin as a tourist with a reporter and me. In those days it was possible for tourists to enter for the day provided they bought a set number of East German marks. Journalists and professional photographers were not allowed though, so I had just one camera and lens for all my photography.

The day started badly. The film company, who had been sworn to secrecy about the trip, had leaked the information to West German TV. As we swept into the square in front of Checkpoint Charlie, they had a camera on a large tripod filming us and tried to do an interview, all in plain sight of the East German border guards on the other side of the bridge that made up the checkpoint.

We crossed the bridge, and were immediately ordered out of our car and into a border control office that was manned by young women in border guard uniforms behind a long desk. Through the window we could see our car being stripped and searched on a ramp. They even removed the wheels.

We handed over our passports and waited, and waited, and waited. After about an hour, Sean walked over to the desk and demanded to know how long we would be held. All Bond films were banned in East Germany, so it was a bit of a shock when the young border guard looked up at him, smiled and said "patience Mr Bond, patience". We all fell about laughing, and a few minutes later we were released to our car.

For the rest of the day we had an unmarked car following us. We visited the Russian Army Cemetery, and the site of Hitler's bunker, now a block of flats. I have to say I was a bit nervous when we had to take a picture of Sean with the Brandenburg Gate behind him. I rattled off a few frames, and then we shot off back to Checkpoint Charlie and the West; we were all relieved to cross the border.

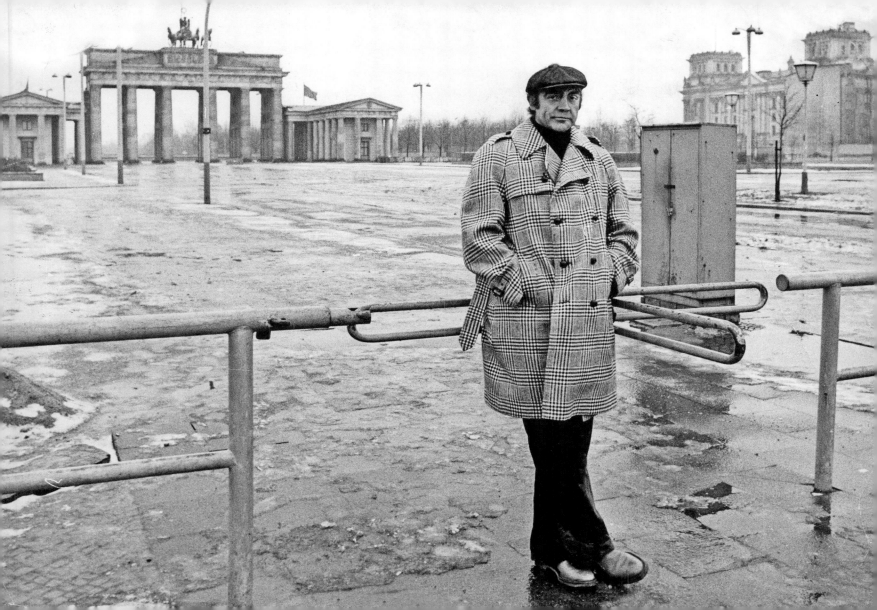

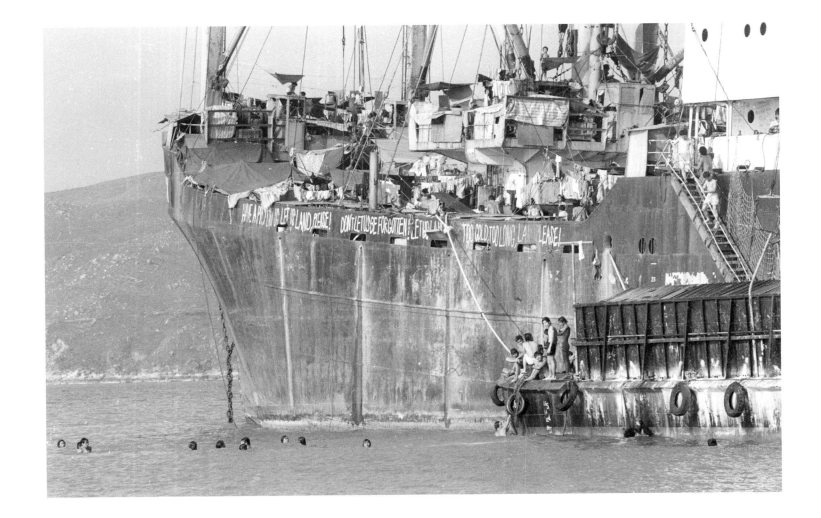

Boat People

In those days life could change in the blink of an eye, as it did one day when I was photographing a new baby deer at Regent's Park Zoo.

A dispatch rider from the office turned up with airline tickets for the mid-day flight to Hong Kong; he was to take my film and I was to go to Heathrow to catch the flight. Normally, this would have excited me, but I was due some time off from that evening. I didn't have as much as an overnight bag with me, and I knew I was off on a mission impossible.

For some days a British ship, the *Sibonga*, had been placed in quarantine in the middle of Hong Kong harbour. The Hong Kong police force was keeping all press and TV well over a mile from the ship which had picked up some 600 Vietnamese refugees – men, women and children – from a sinking boat in the South China Sea. They had two police launches circling the ship to enforce the ban whilst they awaited word from London saying whether the people would be brought to the UK.

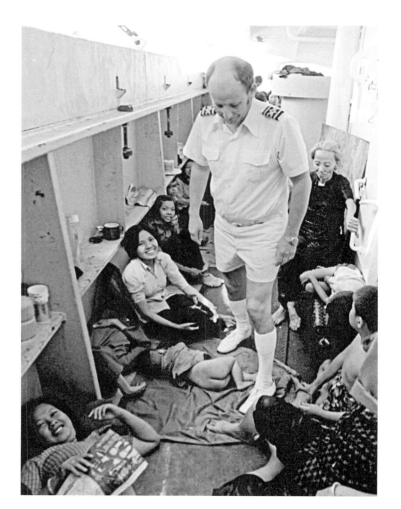

For the entire twelve hour flight I thought about how to bring my situation to a quick end. I did not want to spend weeks 'door stepping' a ship, and I had pressing reasons to take the time off I was due. I decided to make a direct approach to the press office in Hong Kong and tell them I had to get aboard or be arrested trying. I could take a couple of days in a cell, have the *Daily Mail* kick up a stink, and go home a hero.

As soon as the press office opened the next day, I marched in and told them of my intentions. They pointed out that I would be arrested and thrown out, and I pointed out that these were my only alternatives. I also pointed out that if they wanted these people moved back to the UK, then a spread all over the *Daily Mail* would put pressure on Maggie Thatcher and her government. After all, through David English we were the first paper to champion her rise to Prime Minister. If they arrested me and threw me out, people would be asking what the Hong Kong government had to hide by keeping all press off this ship.

He asked me to return to my hotel and wait; he would ring me at noon. I took the precaution of hiring a speedboat for three o'clock in case he checked, then went out to buy some clothes. Sharp at noon he rang and told me he could smuggle me aboard with an engineer from the ship's company, who had to go out to fix the air-conditioning in the main cabins. I could stay as long as he did; the police manning the launches knew nothing about me so I must keep cameras hidden.

As we drove across the harbour in the harbour master's launch, I couldn't believe my luck. Whatever was on the *Sibonga* was still a world exclusive, and I had been given it on a plate.

On the way to the *Sibonga* we passed another large freighter that had been stuck in the harbour for some time. Again, the police had sealed it from the outside world and the refugees had painted signs pleading for help on the side. They had also grabbed any materials at hand and created what looked like a Dickensian floating village of ramshackle huts all over the ship; a load of the refugees were swimming in the sea to cool off.

At last we reached the *Sibonga* and went on board. The captain was very pleased to see me and took me on a quick tour around the decks. The smell was awful; in the incredible heat of the harbour with no air-conditioning or breezes blowing the whole ship stank.

The captain was dressed in immaculate white shorts and shirt, the epitome of a British captain at sea. I couldn't help but smile at the contrast between him and some of the half-naked babies lying around the decks; he had to step over one as he gave me the tour. I was invited to enter the freight holds where whole families were living in tiny spaces, but the heat and the smell made me politely decline.

The captain's wife had set up a hospital in the main cabin for the weaker and older of the refugees. This was where the

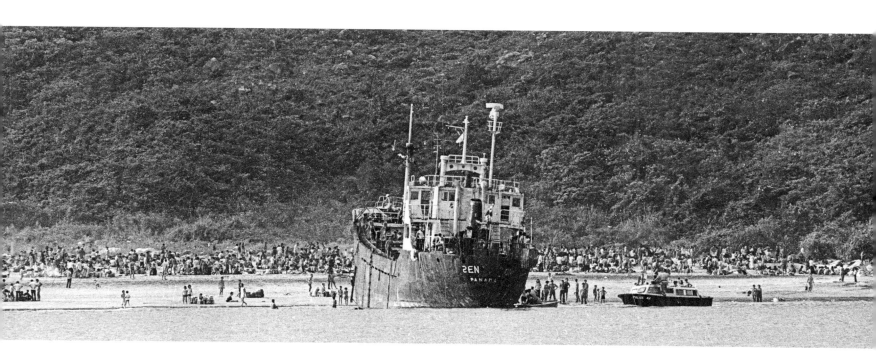

air-conditioning had failed, and where the engineer was hard at work. I wished him Godspeed as I had all the pictures of life aboard the *Sibonga* that I needed, and I wanted to get away before the police became too interested.

We boarded the yacht and the captain and some of the refugees waved us off. Then my next stroke of luck – I had given the assistant harbour master, a young Irishman, a large bottle of Glenfiddich whisky on the way out and that gift now paid back in trumps. Another boat about the size of the *Sibonga* called the *Sen-On* had been filled with refugees in Vietnam and was sailing back to Hong Kong when pirates had jumped ship at Macao and told the refugees to keep the ship straight. It had run up onto the beach of one of the outer islands of the harbour. Again, the police were operating a large no entry policy for a two mile zone around the island. We on the harbourmasters launch were waved through to about 400yds off the coast.

The sight was incredible – the force of the engines had propelled the ship right up onto the beach, and thousands of refugees had streamed off onto the land. The police were trying frantically to get them back on board. I had to work through the glass of the cabin window as the police were watching us closely; on top of the pictures on the *Sibonga* I had enough material to fill the paper front to back.

I dashed to the AP office as soon as I had landed and watched the films process and print. I could see the AP editor drooling at the images I had, and I knew this would be bad news for him when the AP New York editor saw the images he had been trying to get for several weeks. I offered him a compromise, a couple of negatives the day after we published, and this kept him happy. They wired 13 pictures to London for me, and I went back to the hotel and had a huge lobster dinner; I felt I deserved it.

Sunday morning London time I was awakened to be given a roasting by the picture editor for daring to send 13 pictures at $150 dollars a time: did I have no regard for his budget? I suggested he ring me back when he had taken the trouble to get the pictures from AP London and shown them to the editor. A couple of hours later he came on full of praise; the paper was full of the pictures, and the government had commented that something had to be done.

I was taken to lunch by the press officer for the Hong Kong government. He was thrilled with the outcome and had decided to open up the 'Godowns', seaside sheds that had become home to thousands of the refugee . This gave me a second bite at the cherry and I hoped a ticket back to the UK, but no, the picture editor sent me on to Tokyo to photograph the Japanese girls who were being trained to guard Margaret Thatcher at a forthcoming summit. In the end it was two weeks before I could return home.

Introduction – The 80s

The eighties were incredible times for me. By the end of the decade I was covering all major sporting events for the paper, as well as the fashion and news stories. I covered fashion all round the world with Jean Dobson and then Gail Rolfe, and sport with the World Cup in Mexico, the Seoul Olympics, and the arrival and coverage of Zola Budd. There was also the uncovering of Lord Kagan, a friend of Harold Wilson, on the run for tax avoidance schemes; a reporter and I drove him out of Tel Aviv, then confronted him in Spain, forcing him home to face the music. I got to meet Christopher Reeve, Angelica Huston, Prince Phillip, and the legendary Peggy Lee, and I photographed the Pope's visit to the UK. Never a dull moment – and I got paid for it!

I would like to say that this was the time of my life, but it wasn't. The *Daily Mail* left Fleet Street and set up in Kensington, so every day I had to drive in and out. A journey of approximately 20 miles from where I lived was taking two to three hours of driving both ways; it was killing me.

I was considering early retirement and freelancing, when the picture editor gave me an offer I couldn't refuse. The paper was now using colour every day and David English wanted a staff sports photographer to make sure the back of the paper was well illustrated: would I like the job? My reply was instantaneous: yes please!

Being sports photographer meant I no longer had to drive into the office every day; I went straight to the event I was covering. I had my own wire machine and on the big assignments I could hire a young photographer to process and wire my films. It also meant I could pick and choose my own assignments...bliss!

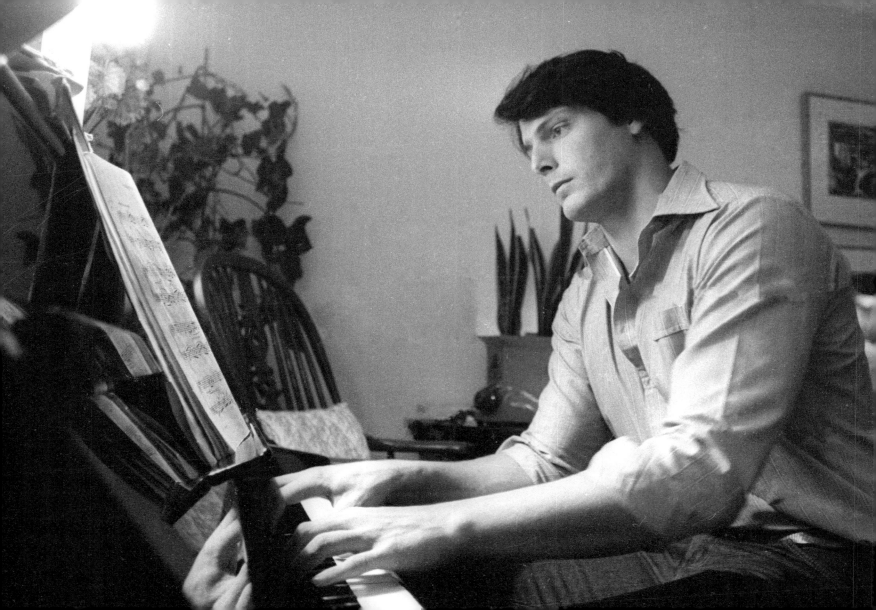

Christopher Reeve

I met Christopher Reeve in the late eighties during a one-to-one interview and photo session in a London hotel. He was a charming man who had the world at his feet; his Superman films were a great success, and he had everything to live for.

I took pictures of him chatting and posing around the suite (we couldn't go outside); he was great company and a good subject. I worked away steadily for the first twenty minutes or so, then sat back and listened to the reporter at work.

When he started to dry up Reeve's manager brought in some refreshments and we all relaxed and talked. There was a piano in the suite, and when asked Reeve played a number of songs.

I used bounce flash and covered several angles, then decided to work with the little available light in the suite. I much preferred these images even though they were grainy and soft; I felt they captured the mood.

When he suffered that terrible fall from his horse, I felt a great sadness. I had found him a pleasant man to work with. He didn't deserve such a fate.

Peggy Lee

Jazz singer, pop singer, songwriter, composer and actress – this was Hollywood legend Peggy Lee. She was in London and had agreed to an exclusive interview with the *Mail*; I was honoured to be given the task of taking the pictures.

We were in a top London hotel for the piece and I sat and listened to the stories of all the showbiz legends she knew and worked with. She asked me not to take pictures until the end, which I did not find difficult, as she rolled off the names of superstar after superstar, and spoke of the wonderful life she lead.

When they finished the interview she turned to me and said "This is the part I have been looking forward to least".

It was obvious why. In her prime she was one of the great beauties of stage and screen, but now she had put on weight and it showed.

She was wearing a Spanish-style hat with a black lace veil, and this suited her. I promised that I would keep the lighting and the exposures 'soft' and that I was sure her fans would like the image.

She wasn't very convinced, but kept to her promise of allowing me to take the photos, so I kept mine and gave the images a soft look.

This really was the 'Lady and the Tramp'.

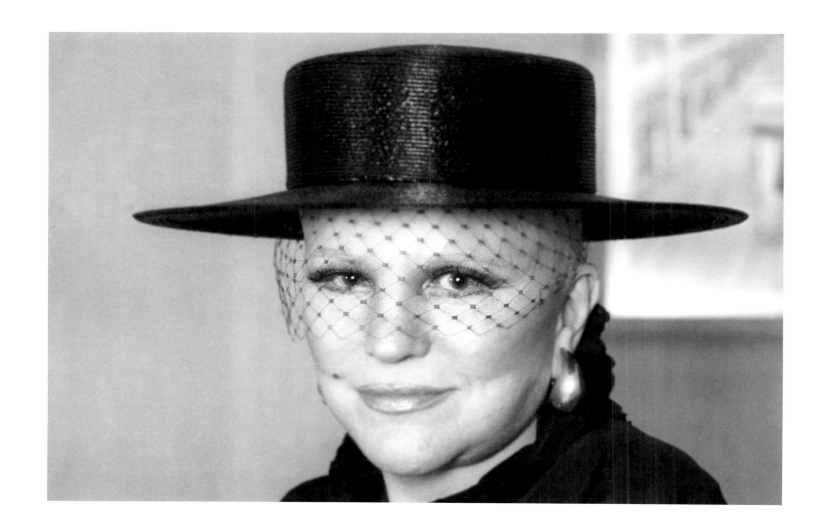

Archbishop Runcie

I started the decade with an exclusive that caused a lot of argument in Fleet Street but which did me no disservice. Robert Runcie was being crowned Archbishop of Canterbury in his cathedral in Kent, and I was given a rota position outside the Great West Door, where he would process in and out. To the right of the press area was a zone full of cathedral staff and families. As Runcie slowly processed into the cathedral, one young mum tried to entice him to the crowd by holding aloft her baby and calling his name, but to no avail; the procession kept moving.

When it came time to leave the cathedral, the doors swung open and out came the new Archbishop with his attendants, followed by the choir in full voice. The young mum repeated the performance with her baby, and this time Runcie started to move out of line towards them. My heart sank because it was obvious that his attendants would block the scene, and there were no photographers on the far side. But

"he who dares wins" and so I vaulted the crash barrier holding us place, avoided the outstretched arms of a policeman, and ran through the choir to arrive just in time to get a shot of Runcie kissing the baby on the nose.

I received my deserved dressing down from the security chief, then hot-footed it back to Fleet Street. I rang ahead to let them know what I had, but I needn't have bothered. When I ran into the office to send my film to the darkroom via the tubes, a deputation from all the other Fleet Street picture desks were arguing about the copyright of the picture: was it rota and would we issue it? I was asked point blank by David English in front of them, and I had to say that as it was *not* taken from the rota position, and none of the other photographers had moved, it was a *Mail* exclusive. This caused even more argument and the air was turning blue, when a phone call from Lambeth Palace decided that any image from within the cathedral grounds had to be rota.

I was disappointed, but I was consoled by the fact I had a beautiful image of an historic event, and most of the papers gave me a by-line. I also received a thank you note from the Archbishop for putting a common touch into a very formal day.

So my most important and enjoyable decade started with a bang. I had now standardized my equipment to 3 Nikon bodies and a series of lenses; these were enough to cover any eventuality, and I had the use of the special cupboard if I needed it.

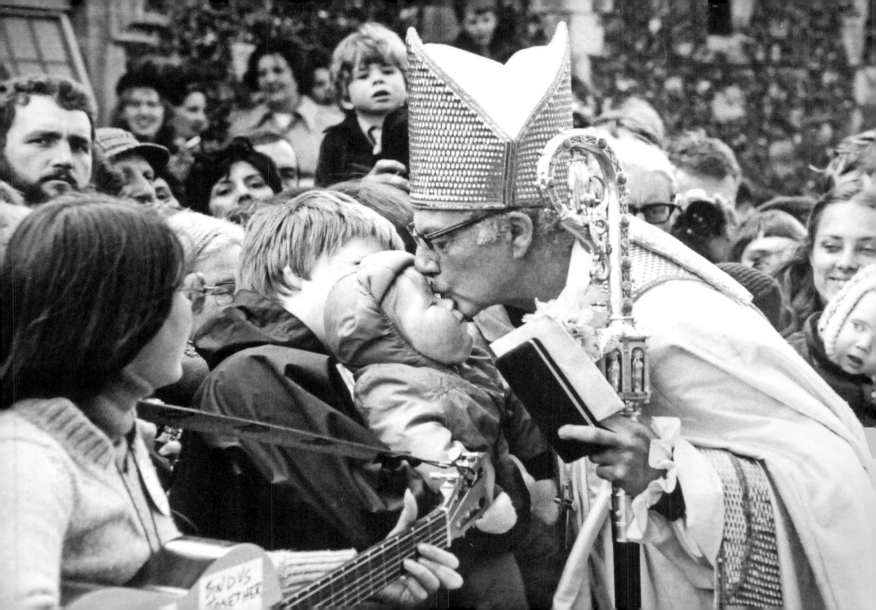

Beetle cars

About this time I found a great story on the toy floor of Selfridges in Oxford Street. Every Christmas when the children were young we would make the pilgrimage to Selfridges, as they had the best Father Christmas. On this trip, as my wife queued with the children, my attention was drawn to a mini Beetle car for children, seven feet long with a petrol engine and real VW parts. I imagined trying to get a Christmassy pic out of it.

The next day I rang up to enquire. The cars were being made in a village deep in Cornwall by a small firm of ex-fishermen and boat-builders who had seen their traditional trades destroyed by EU fishing rules. They could no longer make a living, so converted a large garage and started making these mini Beetles.

There were six men in all; I rang the main man and asked how many cars were on the production line. The answer of "four and some bits" made me enquire again if they could have a 'production' line of cars lined up with the village bobby looking on. He loved the idea, and I was off on a jolly jaunt away from the office for a couple of days where I could not be disturbed. I spent a boozy lunch with the workforce, including ex-boat-builder Pat Strike, in the village pub and told them what I wanted. The next morning we lined up the cars on the garage forecourt (only three of them were in working order), the bobby turned up, and I had my picture. The picture was used as a centre spread, and VW immediately ordered two cars for publicity purposes; the publicity lead to a few sales, and I had friends for life.

Peter Grover, the Deputy Editor of the *Daily Mail* called me in the next day to tell me of a mischievous plan he was hatching. As the Germans had stopped making the car some years before, he wanted to export the Beetle car, symbol of German engineering success, back to Germany: could I fix it? The idea of exporting the Beetle to Germany,

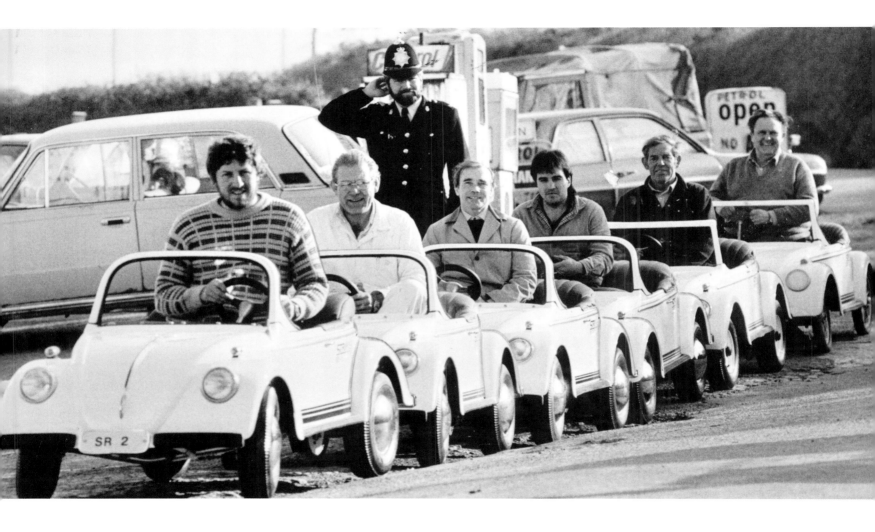

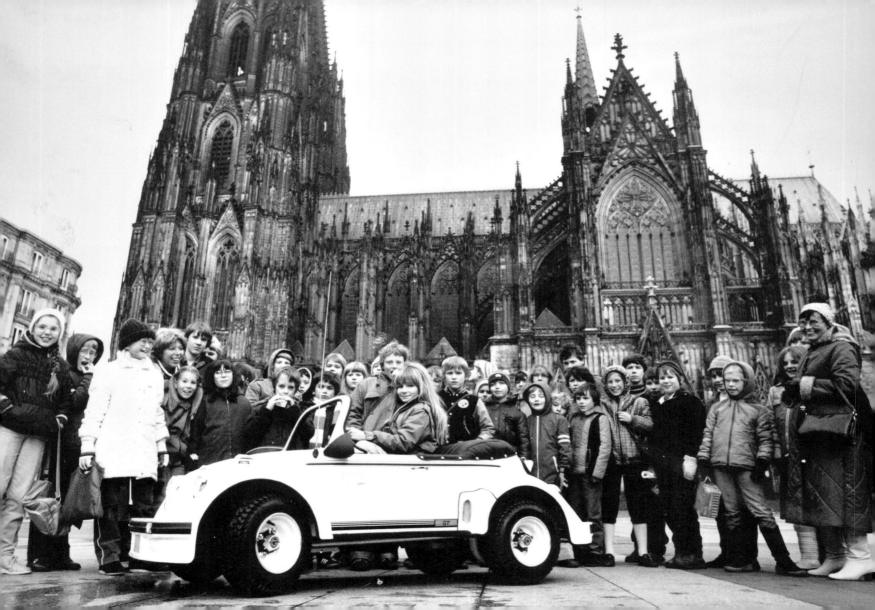

where Hitler had first dreamed up the car, was too good a chance to miss.

I spoke to Pat Strike on the phone and he was very excited: VW had ordered some cars from him on the strength of the *Daily Mail* story that were to grace their VIP showrooms. I rang VW's press office in England and told them of our plans to export the car to Germany; they not only loved the idea, they arranged for one of their staff to drive a car and trailer to Cologne for a picture session. We crossed the Channel and drove into Cologne, where in front of the famous cathedral we drove the car round the front, drawing a crowd of people. Unfortunately, we also attracted some police officers and were asked to move on as we were creating a disturbance. On returning to London we had a front page and centre spread on the Cornish fishermen selling Beetles to the Germans. Not bad for a trip to Selfridges!

Ski car racers

In 1980 I was sent with a reporter to a French ski resort high in the Alps to meet a skier who had written to David English (a ski nut), telling him of his exploits in downhill speed skiing and asking for some coverage in the paper. His name was Jonathon Elabor, a 6'3" black man, unusual for a skier to say the least.

Downhill speed skiing is very different and more dangerous than any other ski event. The contestants find an almost vertical sheet of ice at the top of a glacier then throw themselves down at mindboggling speed. The only control they have are very slight movements of their bodies against the wind.

Jonathon liked to be known as Jonathon E, and he was a natural showman with no fear in his body. He dressed from head to toe in jet black and made an incredibly powerful figure on the snow and ice of the glacier. I spent a day with him and his mate John Clarke, a Scottish lad who at the time was

ranked UK number one, just ahead of Jonathon. High in the Alps looking down on the world was a fantastic experience and I was getting some great pictures. I once built a small slope of snow and ice and with Jonathon perched on it against a low camera angle, he appeared to fly through the clouds.

That evening as we had dinner with them, the little bell in my brain which never let me down started to ring. The reporter had asked if they were able to stay in the Alps for the whole year, and they told him no, they had to return to the UK to earn some money, but they were hoping to try an American idea where the USA speed skiers bolted themselves on top of fast sports cars and hurtled down tracks, recreating the wind effects of the mountains.

I asked if they would perform this for me if I was able to set it up in the UK. Their response was instant: yes please! It sounded simple enough, and when I broached the subject in the office, David English loved the idea, but the managing

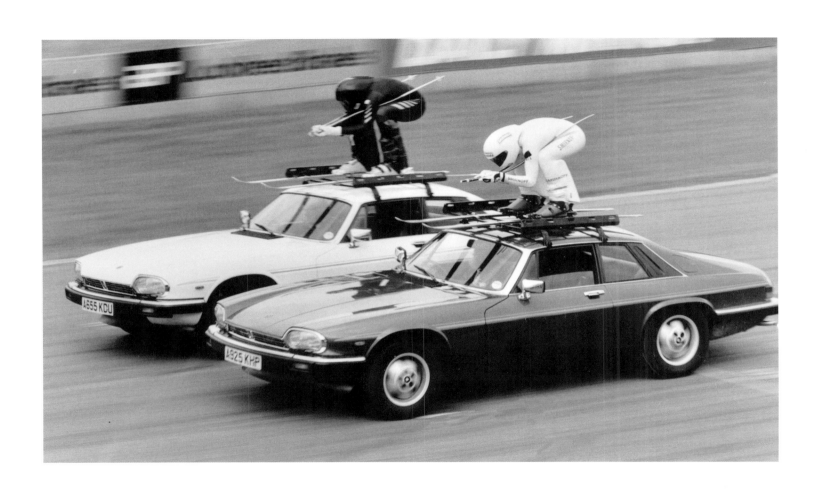

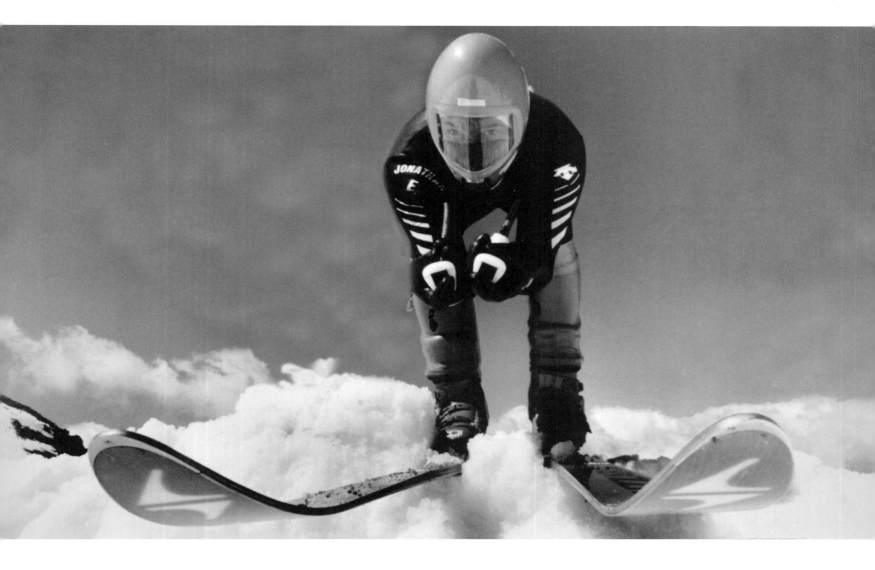

editor didn't. In the end the company's insurance division gave their consent provided they inspected the roof racks and we didn't go faster than 50 miles per hour.

Next, I rang round the race tracks and Snetterton kindly agreed to let us use theirs on a quiet day. I rang Jaguar cars to try to borrow two sports cars and they refused, so I got the *Mail*'s motoring correspondent to ring Jaguar's press office and ask why I was about to use Japanese sports cars for such a good English story, and Jaguar changed their mind. I then purchased two heavy duty roof racks, had extra clamping points attached, and ran two belts round the racks and through the car windows.

The great day dawned and the two lads looked the part, Jonathon in black and John in white. I arranged with the drivers for the far car to be slightly in front at the point they passed me, set a slow shutter speed and then panned with the cars as they hurtled past. I am sure they were exceeding the 50mph speed limit, but who would know? I knew I had a winner in the bag!

Back in the office I had the picture printed up to 20×16 inches and it was taken to David English who loved it. He decided to hold it for the first available centre spread, the best spot in the paper. This came early the next week; the picture covered the entire two pages of the centre spread with the story of how I had managed it. Later that evening, with the first edition rolling off the presses, the news came through they had caught the Yorkshire Ripper. My spread was abandoned, and because the editions overlapped in the country, was never resurrected. Six weeks of hard work had gone down the drain. Some you win, and some you lose.

Mrs Gandhi

Around the Christmas of 1980 I was sent to Northern Pakistan to cover the refugees flooding across the border from Afghanistan, where the Russian army had moved in to prop up a communist leader. Civil war had broken out and the Mujahidin were involved in bitter guerrilla fighting all over the country. I did a couple of weeks of this, then I was ordered to Delhi, where Mrs Indira Gandhi had swept back to power.

When I got to Delhi I went straight to her official residence, where she was standing on a small stage greeting thousands of her supporters as they filed past. I joined the official press party on a stand opposite and took many photographs. I was worried because I was only taking the same images as all the other photographers, and I needed something better. I wandered off the stage and into the crowd, trying hard to find a different angle, but in the end the heat and the smell drove me back to the stage, where I at least had my head in fresh air. At this moment Mrs Gandhi left and went into the house. The government press officer came to us and invited all Indian photographers to go into her private garden, behind a tall wall, for some exclusive pictures. I told him what I thought this would have caused if the roles had been reversed in England. Although he apologised, he said he could do nothing.

At the back of the crowd alongside the road was a police Land Rover, with a ladder leading up its side to a reinforced roof. I made my way over to it, waved my press pass and climbed the ladder. The young Sikh copper didn't know what to do, so he did nothing. As I stood up this image was staring at me. Mrs Gandhi was organising the press pack, standing like a Madonna in her traditional robes. The photographers were all trying to stand on the same square of ground in the centre, and through all this, a huge cow stood in the background. I had my "different" picture; it made the spread.

It is interesting that in this very garden, four years later, Mrs Gandhi was assassinated by two young Sikh guards who were paying her back for invading the Sikh Holy Golden Temple in Amritsar.

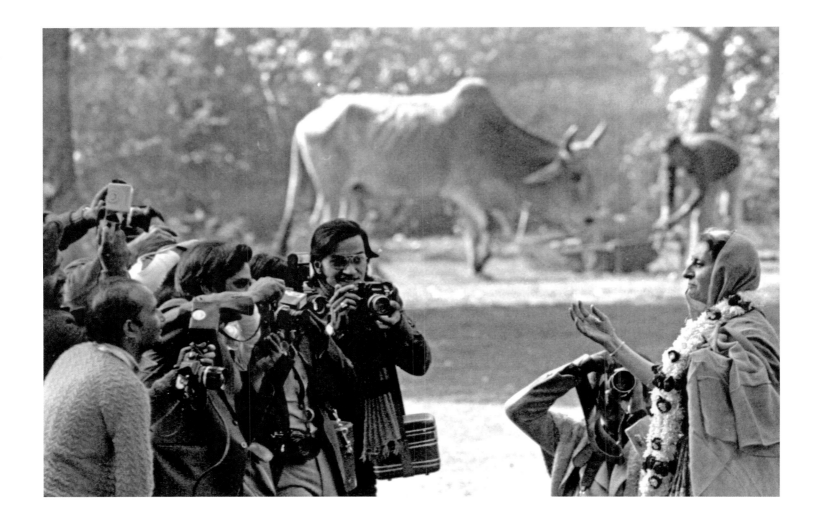

Charles and Diana's Wedding

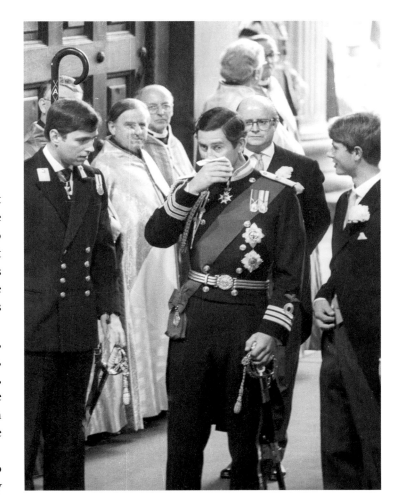

I covered the wedding of Prince Charles to Princess Diana in St Paul's Cathedral. I was assigned a rota position just inside the Great West Door, and here with other photographers I was to cover the arrivals. To get into this rota position we had arrived at the side door of St Paul's some three hours before the first guests were due. We had been given a raised platform about 4 ft. above the floor, and just before the wedding started a line of Beefeaters stood in front of us carrying their long ornamental spears.

First the congregation arrived, then ex-prime ministers, followed by Maggie Thatcher. The royals all arrived on time, then a very nervous Prince Charles attended by his brothers, and at last the bride and her father. As the bride walked in, the Emmanuels who had designed her dress rushed forward with the bridesmaid to try to get all the creases out and make the very long train lie flat.

As the bride processed up the centre aisle we were able to relax, as all the action was at the front. I can remember every

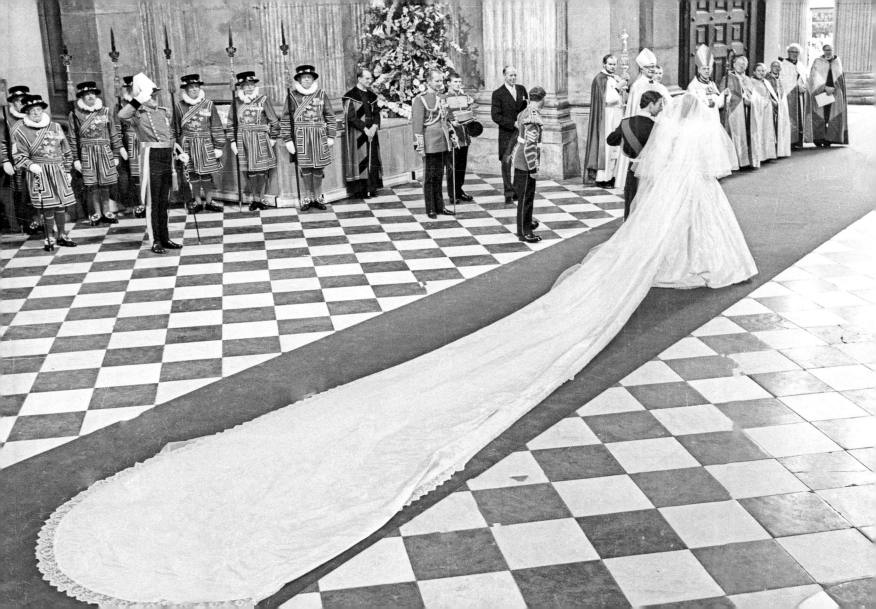

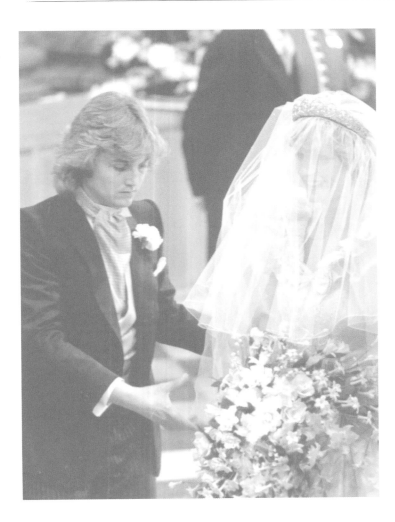

hair on my body standing up as the beautiful sound of Kiri Te Kanawa resounded around the building; the sound was incredibly pure and we could hear it as clear as the people at the front. As the bride and groom left we had a superb view of the long train.

Margaret Thatcher

In 1982 Maggie Thatcher led a war against the Argentinians over their invasion of the Falkland Islands. I honestly do not think that any other Prime Minister, apart from maybe Winston Churchill, would have managed such a massive task. The Ministry of Defence held a ballot to get two still photographers on board for the trip, one from the PA and one from a national newspaper; I was informed by the picture editor that my name had been put in for the *Mail*. I had great pleasure in telling him to get it off the list, as I suffered seasickness on the ferry to the Isle of Wight and I would not survive beyond the Solent.

After the conflict was over I was assigned to go aboard the aircraft carrier *Hermes* as she returned to Portsmouth. We were taken out to the ship in a landing craft, given a tour of the flight deck and then shepherded into the area by the conning tower as a mystery helicopter landed – out stepped Maggie Thatcher smiling broadly as she prepared to tour the ship. My first shot

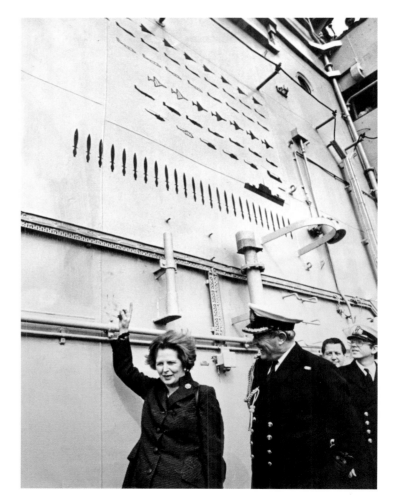

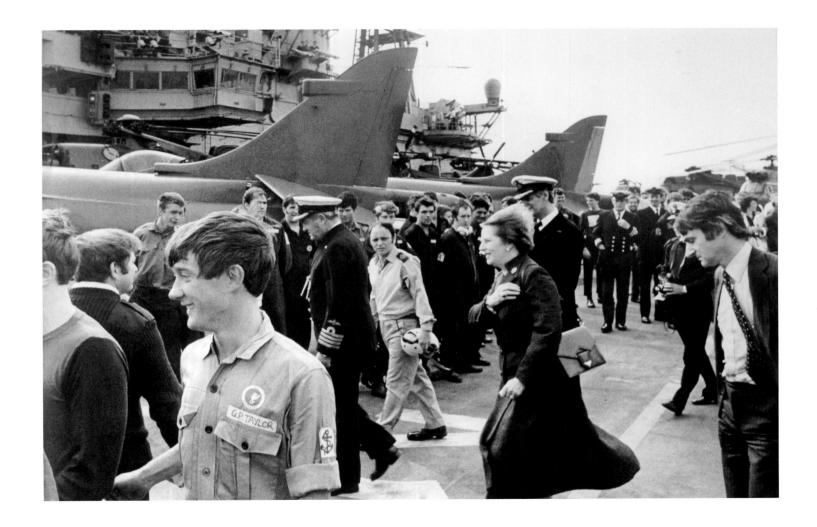

of her coincided with a gust of wind lifting her hair; this shot was used as a spread in the *Mail*, and I could not match it until the last few minutes. As she prepared to leave she asked "did we have all we needed?" We pointed out that on the other side of the conning tower all the battle honours of the trip had been painted on the wall, and a picture of her with them would be good. We had already been told by the Navy Commander in charge of the press that this would be in poor taste, but Maggie was having none of it; round the corner we all marched and she proudly pointed up at the images. Job done.

No 10, 'Maggie's Den'

The title rolls easily off the tongue and everybody is familiar with this 'bingo call' but for me it brings back memories of one of the most incredible hours of my life.

It was about four weeks after the end of the Falklands War. The whole country was still in a state of euphoria and David English (the *Daily Mail*'s editor) was invited to hold the first head-to-head interview with Margaret Thatcher at 10 Downing Street. The interview was to be for one hour and I was given the honour of taking the pictures; I would take pictures for the first five minutes and then leave. The *Mail*'s team of David English, his foreign editor and myself arrived at No. 10 in a chauffeured limousine, went through the intense security and were then ushered in by the doorman. We walked up the famous staircase past the portraits of all the previous Prime Ministers to be greeted by Maggie herself.

She shook each of us by the hand and then we went into her 'den', a large room decorated in a homely style with a magnificent marble fireplace but no fire, just a small insignificant electric convector heater and, I must say, instantly forgettable tables and chairs.

Mrs Thatcher immediately sat on the left of the fireplace (how appropriate) and David sat on the right. The two 'aides'

set up their tape recorders, switched them on, then sat back as the interview began. I used my five minutes shooting with bounce flash and direct flash as there was not enough light to shoot without. I moved from side to side to get the best angles then I noticed David English getting fidgety, so I stopped and put my cameras down. I whispered to her aide that I was ready to leave, but he ushered me into a chair, and told me to stay, but no more pictures.

I was transfixed as David questioned her about every aspect of the war and where we would go from here. At one stage he told her that rumours was circulating on the street (Fleet Street) that the USA were going to rearm the Argentinians. He had no sooner got the words out of his mouth when she snapped at him, 'David. I was talking to Ronnie on the phone last night; it will not happen!' She was referring to Ronald Regan, the President of the USA, and here was I listening in.

On the way back to Fleet Street in the car, the atmosphere was electric. English was jubilant at how much he had got out of her. I was jubilant too, until my negs came down from the darkroom, over developed and grainy. The shop steward for the printers said it was 'all my fault', thank God nowadays for digital images!

Maggie giving David English the first world-exclusive interview after the Falklands conflict

Queen Mother

In 1982, I was assigned to cover a visit by the Queen Mother to a barge in St Katherine's Dock near the Tower of London. It was part of Operation Drake Fellowship, a charity course for young unemployed people set up by her grandson, Prince Charles. She was 82 at the time, but insisted on climbing into the barge to see some of the youngsters at work.

When she emerged from the hatches to meet the rest of the crew, she was confronted by heavy rock fan Alan Skilton from Guildford, complete with heavy leather and brass studded accessories, thick soled suede shoes and torn jeans. He had at least removed his denim jacket with the word 'anarchy' on it. We all waited for a reaction from the very traditionally dressed lady in lilac silks and lace with a grand flowered hat.

She chatted happily with the youth and the contrast between the two could not have been more marked, she with her small bunch of flowers, he with his heavy metal accessories. Two very different lifestyles had come together and warmed to each other.

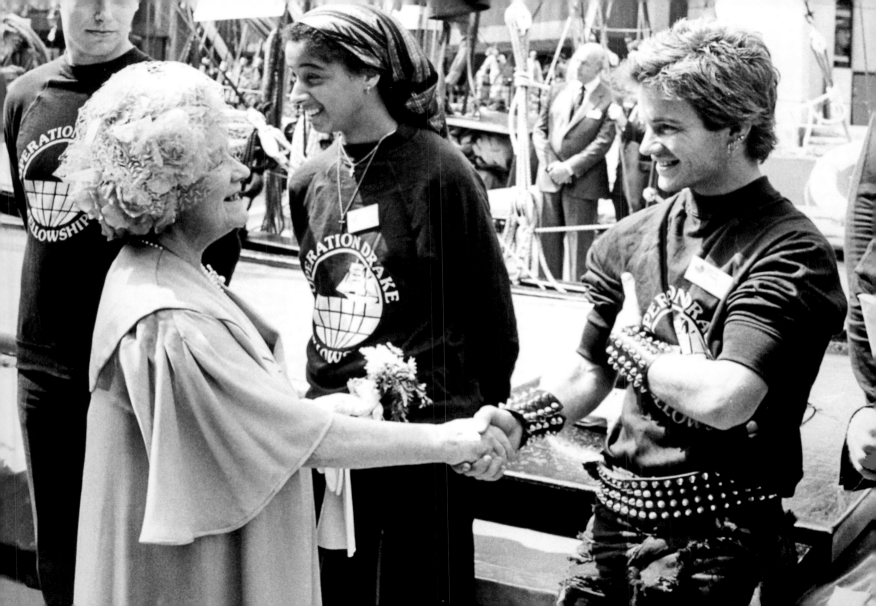

Pantomime with Elton John

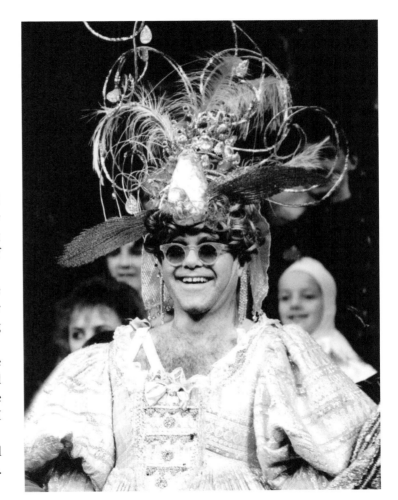

On December 6th 1984 I had the privilege of attending a full dress rehearsal for *Mother Goose* at the Theatre Royal, Drury Lane. This was a one night only charity spectacular starring Elton John and Sir John Geilgud, two of the all-time greats of British entertainment.

80-year-old Sir John Geilgud was playing Egg Yolk the First, the king of Gooseland, and Elton was playing poor villager Elton Watford. This was a reference to his being chairman of Watford Football Club, his local team.

They went through the full panto with many costume changes and brought the house down with a Flanagan and Allan routine, where they marched up and down the stage singing. Even though I didn't approve of their private lives, I was spellbound by their performances.

Elton John in full ballgown for the finale is a sight I will never forget, and I left the theatre whistling one of their tunes.

In pantomime, everything is acceptable!

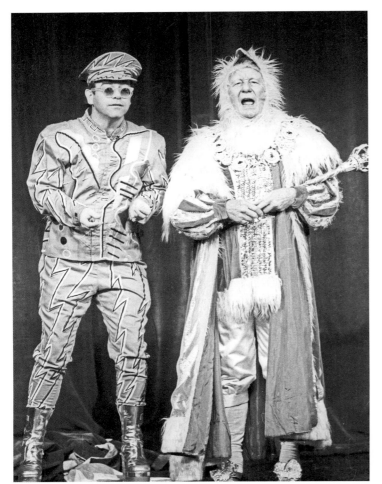
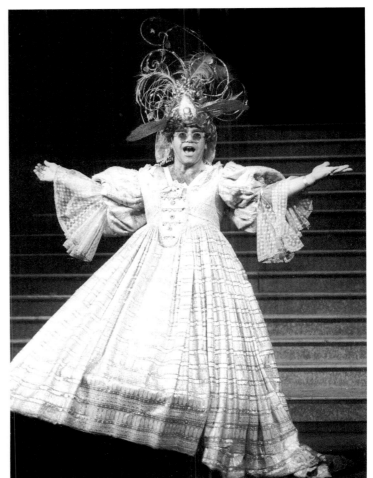

Marie Helvin

It was a typical piece of David English mischief. The beautiful Marie Helvin had just announced her divorce from David Bailey, the legendary Cockney photographer who had discovered her as an unknown and turned her into a super model, allowing no other photographer to work with her.

David English wanted the *Daily Mail* to be the first newspaper to publish fashion shots of her not taken by Bailey. As the paper's own Cockney photographer, I was asked to shoot the photographs in the usual *Daily Mail* style: simple, strong, uncomplicated images, and I must shoot at least one swimsuit. When I asked if this had been written into the contract, he gave a mischievous smile and said "not written, but agreed in principal." The alarm bells started ringing.

We hired a studio at Holborn Studios, and Gail Rolfe, the fashion editor, had put together a large selection of outfits. The agreement was for her to wear four outfits of her choice, but the alarm bells really started jangling at her first words: "I don't do swimsuits". Gail and I explained the brief we had from David English and insisted we had to have a swimsuit, but Marie remained adamant. I then took my life in my hands and explained that if we weren't doing a swimsuit, the whole shoot was off, as my head would be on the block if we didn't! I told her I could not understand her reluctance as we were the *Daily Mail*, not a smutty red top. Then I threw in the clincher: she had been published many times by Bailey stark naked.

She was incredibly professional and gave in with the words "You *have* done your homework". So the session began with the swimsuit she chose (in case she changed her mind), a stunningly simple black costume, modest, eye-catching, and with a large button holding the deep cleavage together. She looked great.

I decided to keep to a simple off-white background with some rim lights on the sides and on her hair. I had a young

studio assistant supplied by the studios to take light readings and help with any movements. Normally the assistant stayed with you throughout the shoot, but this guy explained he was working two studios side by side. I was happy with this and after he'd set the lights he disappeared, only to return ten minutes later to 'borrow' the light meter. I noticed him studying the changes I had made and at Marie's posing, then he went again.

He repeated this performance twice more; the studio door lock was broken, and each time he just barged in. On his third visit I put my camera down, grabbed him by the shirt and threatened dire consequences if he came back again. Then the penny dropped. I demanded to know who he was working for in the next studio. Sure enough, the answer was David Bailey; he was in the next studio, what a coincidence!

We dashed back to Fleet Street with the films, and David English edited the pictures himself. He had a proof set printed up and sent to Marie for her comments, and she was interviewed as to her thoughts about working with another photographer. Thank god she was charm personified, and complimentary about the pictures. She never even mentioned her reluctance about the swimsuit images!

Diana Ross

In February 1986 the subject of my first professional shoot back in 1963, Diana Ross, was to marry a Norwegian mountain climbing millionaire Arne Naess in an 11th century church in the Swiss village of Romainmotier, in the mountains above Lausanne.

Unlike today's showbiz weddings which are sold for millions to celebrity magazines, this couple wanted to keep the wedding as private as possible, but they had released the time and date, so a large press gathering outside the walled church had built up when we arrived.

The bride and guests were preparing in the town's hotel about 50 yards from the entrance to the church; the plan was for them to walk across to the church on a wide red carpet that had been placed over the snow and ice. The press had been given a position outside the church walls where we would only briefly be able to see the arrivals and departures. We would also be standing in a puddle of ice and snow.

We pointed out to the PRO in charge of the proceedings that this was not good enough; that we hadn't come all the way up the mountain for this. But he was adamant; these were the wishes of the bride and groom – take it or leave it! While the arguments went on, I said to the PRO, "If I can't take pictures, I intend to have a snowball fight" and picked up a handful of snow, compressed it and lobbed it over the church wall. Several of the other photographers followed, and the PRO hastily called up two police officers in charge of the small force present.

They pointed out that they couldn't possible cover 100 yards of wall on that side, so the PRO disappeared to take advice. He emerged beaming several minutes later to inform us that the bride and groom would be happy for us to be inside the churchyard, but under no circumstances inside the church. We were happy with this compromise.

After the service Diana and Arne emerged from the church under an arch of mountain axes formed by Arne's

climbing pals. The yard has been lit by flaming torches, and Diana and her bridesmaids in traditional Belgian lace dresses looked enchanting. I did not want to lose this ambience, so I set my shutter on a slow speed, lens wide open and added flash to fill in. It worked a treat. The security for the wedding had cost $1 million, a waste of money in my opinion.

I remember thinking what a happy couple they made, he 47 and she 42, and that here was an old-fashioned style marriage that would last, but fourteen years later they parted.

Bluebell Dancers at the Lido

In 1986 I flew to Paris with a large BBC press party for the premier of their new series *Bluebell*, starring Carolyn Pickles as Margaret "Bluebell" Kelly, founder of the famous dancing troupe. We were treated to first-class travel all the way to the world famous Lido de Paris, where a troupe of very tall, beautiful English girls performed. Margaret Kelly, herself a dancer, had formed the troupe in 1932; she called them the Bluebell Girls after her own nickname gained from her amazing blue eyes.

We were treated to a superb meal with all the best food and wine and then a show by the girls before they joined us in the stalls for pictures and interviews. I think my wine must have been off, because I was cracking jokes and telling everybody how easy their dancing was. When I was surrounded and attacked by six of the feathered dancers, I fought hard for my life and dignity, but I was dragged screaming onto the stage, put in a line and told to show how easy it really was.

The band struck up and our chorus line proceeded to produce high kicks; you can see the terror on my face! After a short routine I was allowed off the stage, with a pulled muscle in my leg and not one of them offering first-aid! Eat your heart out Gene Kelly!

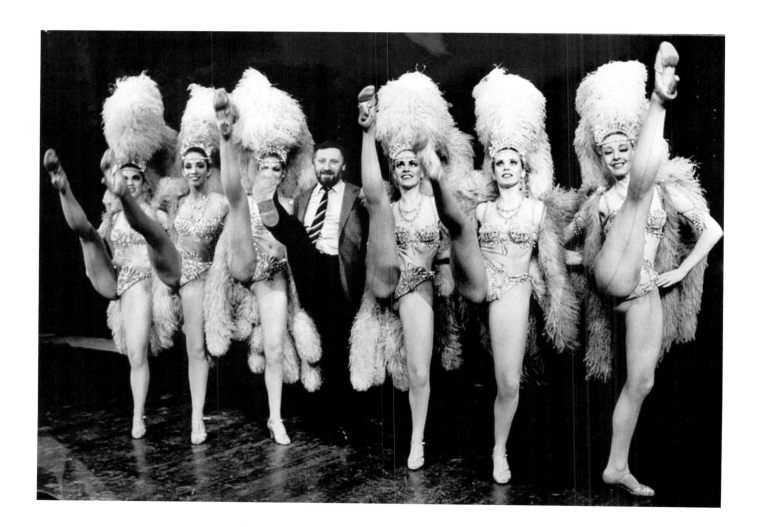

Prince Andrew and Sarah Ferguson

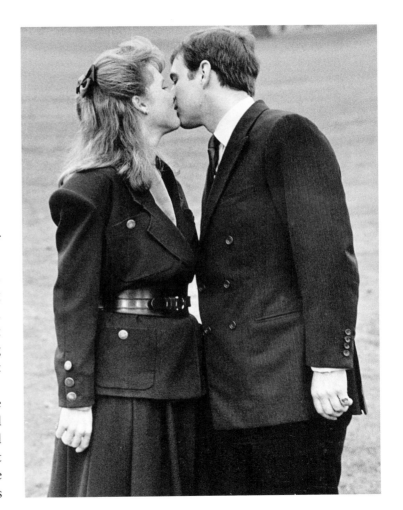

My next heart-stopping assignment was to cover the wedding of Prince Andrew and Sarah Ferguson, but first I must tell you about the engagement photo call in the grounds of Buckingham Palace. I was assigned to the rota party late in the day as the royal photographer of the *Daily Mail* had a falling out with the picture editor. I joined the party carrying two Nikon cameras, one with a standard lens, and one with an 80/200 zoom lens. Both were fitted with motor drives, but I had been having trouble with one of them; it kept running for three frames, then stopping dead, and the only way to get it running again was a sharp bang on its back.

We followed the royal couple all around the palace gardens, asking for the "kiss" picture that his brother and Diana had made on the balcony of the Palace for the world to see. Again, the reluctance came from Prince Andrew, not Sarah Ferguson. After ten minutes of verbal sparring the Prince said "we will do this once, do not ask for a repeat". As

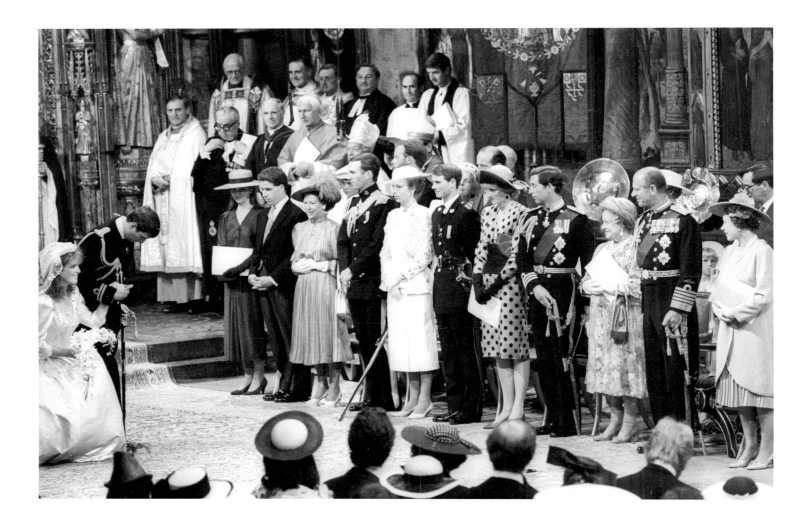

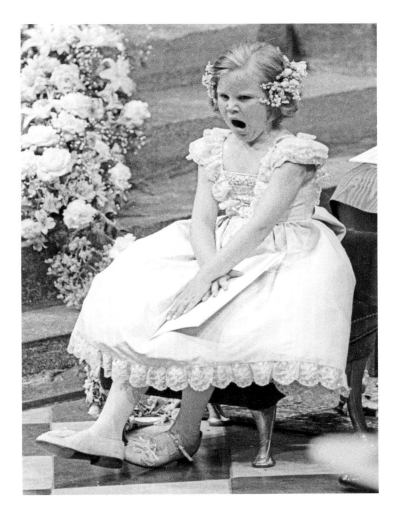

we all settled on five yards, their heads slowly came together. I pressed the button and after three frames my motor drive stopped dead. The couple completed the brief kiss, turned and walked back into the palace. I froze in fear. Had I got the "kiss" or a big miss? Back in the *Mail* I processed the film myself, held the wet film to the light and was relieved to see this image; it wasn't quite the kiss but it was good enough for the editor to approve of the fact we could see both faces.

For the wedding a few months later I was assigned to a rota position to the left of the high altar. The entire royal family were lined up about 8 to 10 yards in front of me, and my thoughts were all of my old headmaster and what he would think of his "dustman" now.

The main picture we were to produce was the couple making obeisance to the Queen after they had left the signing of the register. We had been in the Abbey the night before to watch a rehearsal with models representing the main figures. The royal couple were to leave the vestry and proceed towards the Queen on the end of the row of royals; at a marked spot they were to stop, bow and curtsy, then proceed down the aisle. It was perfect shot on an 85 mm lens and this is what I opted for. As they walked toward the Queen, Prince Andrew panicked. They stopped two yards short of the mark and made their obeisance; on an 85 mm lens, it was just possible to keep the bride and groom on one side and the Queen on the other. Several of the photographers and TV cameramen were caught

with lenses too long to cover the scene, so the air was thick with whispered oaths and swearwords.

I had been watching one of the young bridesmaids, sitting to the side. She was bored out of her skull and kept yawning, but always behind her programme. I watched and waited; she saw me looking down the lens at her, and it became a battle between us. Eventually she succumbed with a massive yawn without the programme – a very human picture on a very formal day.

Among the excitement of Andrew and Fergie's wedding back on the editorial floor of the *Daily Mail*, the female editor came out and asked if there were any pictures of Princess Anne giving withering glances at Princess Di's dress. The main picture of the royal women in the line-up, shows them all wearing mid-calf hemlines on dresses of lace and silk, all very traditional and proper. Princess Di had chosen to wear a spotted dress, cut at the knee so that when she sat she displayed a little royal leg. With her Paddington Bear style hat, you can see why Princess Anne disapproved.

I hadn't noticed Princess Anne's attention to Di's dress. I raced up to the darkroom and went through the negatives with a magnifying glass. I found this one which fitted the bill a treat. Princess Di is seated next to Prince Charles, happily watching the proceedings, unaware of her sister-in-law's glare.

As I have said, I didn't notice these glances but TV must have shown them and the writer felt here was a point to be made. They were never going to get a comment from the Princess, so it was a matter of conjecture. What do you think?

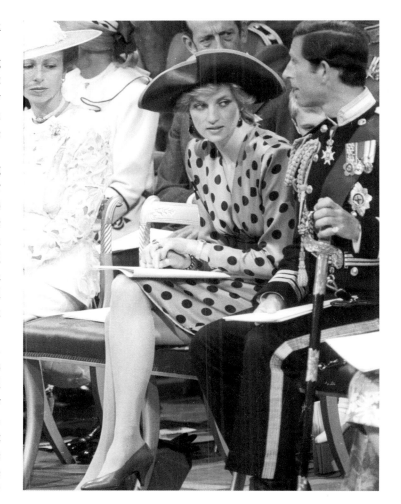

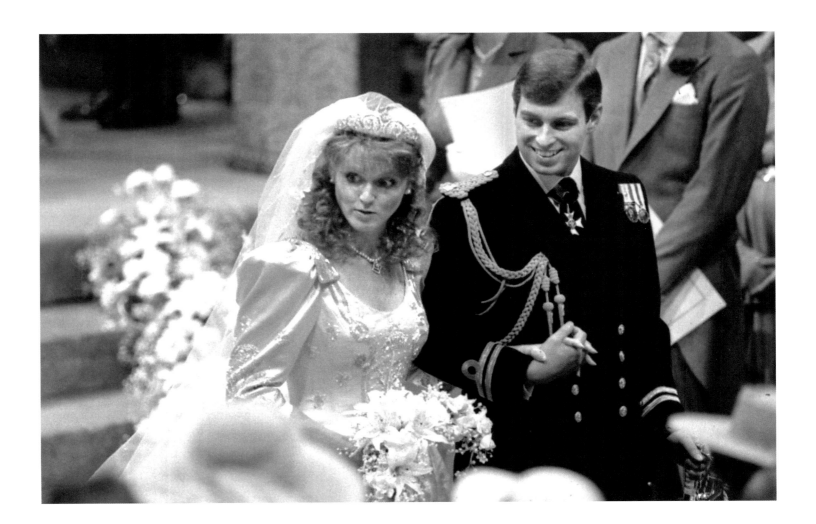

Reagan and Gorbachev

In October 1986 I was sent to Iceland to cover the peace talks between President Ronald Reagan and the Soviet leader Mikhael Gorbachev, which were taking place over two days at the Hofdi House just outside Reykjavik. The Hofdi House was a government meeting house used for entertaining VIP guests. The talks had been requested by the Russians in a direct letter to Reagan some weeks before, to try to reach an agreement on nuclear weapons.

The talks were in two sessions each day, and lots were drawn to see which photographers would be allowed onto the photo stage in front of the house each session. The stage was about 30 yards from the front door of the house, so a 300mm lens would be perfect. I was drawn for the second session on the first day and the last session on the second day, when the talks would end.

On the first morning I travelled round Reykjavik following Raisa Gorbachev, the Soviet leader's rather glamorous wife, as she visited some schools and a hospital. With the *Daily Mail*'s love of all things women I had enough for a good spread. Then in the afternoon I took my place on the photo stage for the arrival of the two leaders. Reagan welcomed Gorbachev at the front door with a typical Hollywood greeting, all teeth and arm pumping; Gorbachev responded with equal warmth and they went in. These pictures and the Raisa Gorbachev pictures gave me a front page and a couple of pages inside the paper.

On the second day I repeated my coverage of Raisa, then hurried to the Hofdi House early to claim my position, as I knew a lot of photographers without passes for this session would try to gatecrash. I found a good position in the middle of the stage directly opposite the doors, and then settled down with the rest of the press corps to wait for the final scenes. It grew dark and the floodlights provided for the TV crews were not all that great. I didn't want to use flash for fear of the

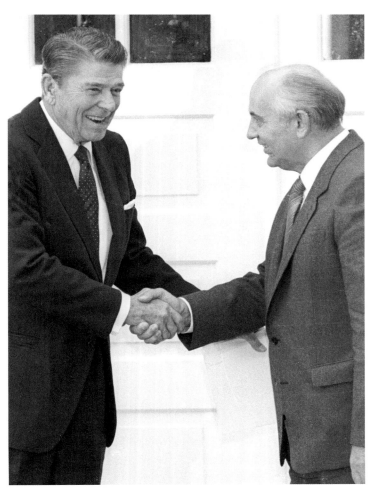
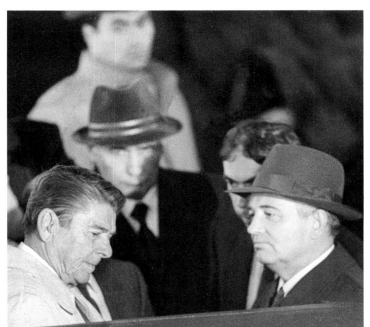

dreaded redeye, where the light from a flash travels through the eyeball and shows the blood behind it. I loaded up with fast film and prayed.

When the doors finally swung open it was very obvious that all was not well. The smiles and good humour were gone; the two leaders briefly shook hands then walked to the waiting cars. For a few seconds Gorbachev fixed Reagan with a very cold stare; Reagan seemed embarrassed and lowered his head as he got into his car and drove off. This was a clever piece of acting from Gorbachev, as it appeared that Reagan was at fault for the complete breakdown in the talks.

What a difference a day makes!

Glenn Close

My shoot with Glenn Close was in a suite of rooms off St James's in London not long after she had sprung to the top of the film industry playing a vicious *femme fatale* alongside Michael Douglas in the 1987 hit *Fatal Attraction*.

She had elected to hold a short session with each paper's photographer in the same rooms so that she could compare the coverage. I thought it a great idea, and enthusiastically set about my shooting time. She was dressed in a very stylish Armani suit and silk blouse of a fawn colour; her hair was short and her make-up perfect.

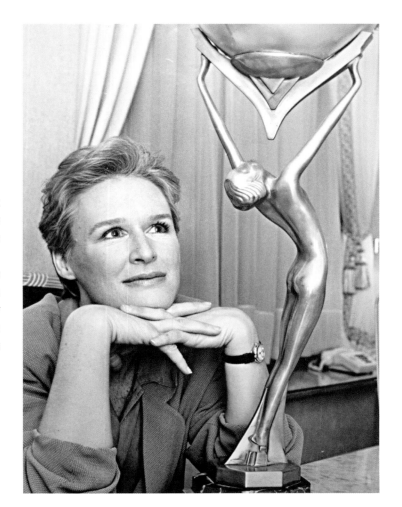

I decided to work round an elegant piece of artwork in the suite as a contrast to her sharp facial and hair lines, then I fell back on one of my favourite backlight situations by placing a slave flash behind her to give the image some force. She was charm personified as we chatted and worked, and I was pleased that I was shooting *my* work with no interference from other photographers.

The pictures were used over a whole page and I was very happy with them.

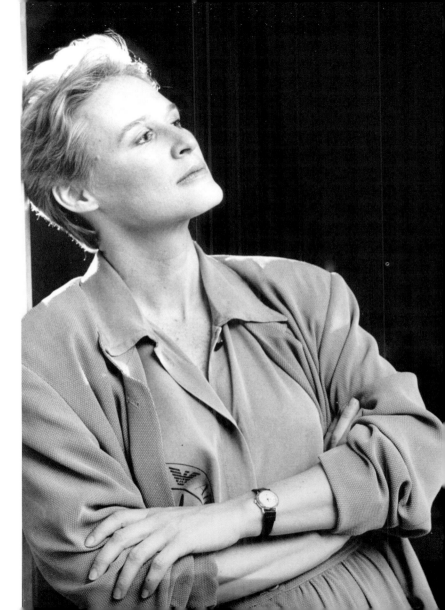

Passion for Fashion

In 1987 I was about to leave the office to go home for the bank holiday weekend when the editor of *Femail* came rushing up to the picture desk with a *big* exclusive they had been offered. A unique collection of outfits covering the entire 20th century was about to leave Paris for Monte Carlo to be sold, and the *Mail* had been given the chance to photograph it. The collection was in the Royal Monceau Hotel in the city centre, and was the personal property of a Scottish lady called Mary Vaudoyer. A former captain in the Secret Service during the war, she had married into a French aristocratic family, and her husband had been a diplomat. She had a reputation for being a tough cookie. She had refused all offers from other papers to photograph the collection, but being a *Daily Mail* reader she decided to give us three hours to photograph the collection at the hotel before it was packed up and shipped to Monte Carlo. The pictures had to be shot inside the hotel, and the Royal Monceau gave us a large suite for the purpose.

We arrived early next morning on the doorstep of the leading Parisian model agency to collect a size 12 model and a make-up team. The doors were firmly bolted! A few frantic phone calls later, a bemused girl appeared to inform us that our booking had been completely forgotten in the rush to get away for the bank holiday. She started to ring all of her contacts, with the fashion editor screaming threats of lawsuits, bad publicity and far worse.

In the middle of all this anger and mayhem I answered a knock on the office door, and there stood a beautiful young Austrian model with her portfolio, hoping to find work. I dragged her in and looked through her sparse portfolio, checked her dress size and then announced to the agency girl and the fashion editor that this girl would do; all she had to do was wear the clothes for stills. The agency girl objected, but we threatened massive repercussions, so we got our model.

Femail Exclusive

One woman's passion for fashion

A unique wardrobe of breathtakingly beautiful dresses goes under the hammer next month at Monte Carlo. The Mary Vaudoyer Collection will be the most opulent sale since the Windsor Jewels. Anthea Gerrie met the Scot whose elegance dazzled Paris

1920 Black and Gold Vertical Striped Tabard of black velvet and gold lamé, with beaded medallions to each hip, over a black underdress

1925 Brocaded Evening Coat, woven with flowers in multi-coloured pastel shades on a silver ground, high, ribbed salmon pink velvet collar and trim

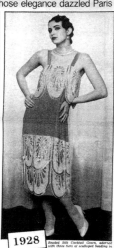
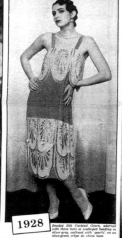

1928 Beaded Silk Cocktail Gown, adorned with three tiers of scalloped beading in silver-grey, outlined with 'pearls', on an olive-green crêpe de chine base.

1934 Printed Crêpe Trained Evening Gown, possibly by Schiaparelli, plunging neckline emphasised with black velvet, down curving waistband with weighted panniers. Photographed at the Royal Monceau Hotel

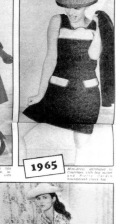

1956 Fine Black Piqué Silk Ottoman Tent-Coat, labelled Balenciaga, with square-end collar

1965 Mini-dress, attributed to Courrèges, with boxy jacket and Pierre Cardin houndstooth check hat

Dedicated follower of fashion Madame Mary Vaudoyer

How this love affair with clothes began

MARY Vaudoyer's passion for clothes began when she was very young, in Scotland.

'Clothing served one purpose only — to parry the fierceness of the icy winds and the moisture of the winter sea. No interest in aesthetics was ever evinced,' she says.

But after falling on a copy of Vogue and a Butterick's pattern book at the age of six there was no looking back for the woman who was to become the toast of Paris society, renowned not only for her clothes but her daring in defying convention by wearing them decades out of their time when current fashion had ceased to take her fancy.

She says: 'The day I left Cheltenham Ladies' College and put behind me the most unbecoming uniform ever conceived, the chase was on.

These days she can give you a dissertation on the faults and virtues of Alaïa and Comme des Garçons as well as a lecture on fashion at the fin de siècle.

She never received a flicker of encouragement from family or friends, but rather stark incomprehension.

'Even my sister-in-law,' she says, who was Poiret's great-niece and should have known better, would watch me sautéer's webbing with human hair and flatly ask: "Why don't you just go out and buy yourself some new clothes?"'

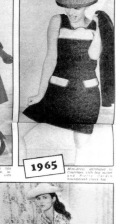

1968 Chanel Printed Mohair and Silk Tweed Suit, green, orange and turquoise on ivory ground, with gold chain

Her couture was the talk of the town

MARY VAUDOYER is a Scotswoman of uncertain age but unmistakable taste. A one-time darling of the parisian beau monde, a wartime captain with the Secret Service and the owner of a remarkable collection.

Her wardrobe is a dazzling Who's Who of haute couture. Two hundred designer gowns, coats, suits and hats that span a century of fashion. There is Chanel, both very early and very late, there are Patou, Dior and Grès; there is Balenciaga, still looking shockingly contemporary. There are treasured Poirets of the Twenties, Lanvins and Givenchys of the Sixties, and some 75 fabulous beaded dresses, a legacy of a thousand glorious party nights between the wars.

Next month she will make another

dramatic entrance as guest of honour at Monte Carlo's Sporting d'Hiver... and watch her life's passion disappear under the auctioneer's hammer. The occasion will be Sotheby's black tie sale of the Collection Mary Vaudoyer on October 10.

And so the hidden battle for jewel after fabric jewel, Miss Vaudoyer will wave farewell to her unique fashion hoard, without so much as a single, secret tear.

After all, I've had all the fun of them, she says, flashing a dazzling smile over the champagne we are sipping in her favourite restaurant in the elegant Royal Monceau Hotel.

And so adieu to the 1927 black georgette sequinned cocktail gown that she lovingly restored and then shocked Paris society by daring to flaunt it on

Maxim's dance floor in the Swinging Sixties when Courrèges was king. And to the 1934 printed crêpe evening dress — almost certainly a Schiaparelli — in which she made guests faint when she appeared in it, slit to the waist, at a high society Paris ball.

Miss Vaudoyer's childhood dreams of beautiful clothes because real when she discovered Paris, Schiaparelli and the fact that if you had a 20-inch waist you could buy cut price couture by reserving the mannequins' models for the end of the season. Then war broke out, putting the young Foreign Office administrator into uniform.

She rose to captain in the Secret Service, not at all put out by the repetition of daily uniform. 'I would gladly return to the deep peace of the khaki shirt,' she shrugs.

Returning to Paris in 1944, she married into a dynastic, well-off family and found herself spun into a round of parties and balls. But for all the excitement, she felt a deep ennui about current fashion in the mid-Fifties and started plunging into the antique shops for sartorial inspiration. And so her collection grew.

But now she feels the collection must go. 'There is simply not the time and expertise available in the family to look after them. There are young children, and it is just not possible to explain to someone else how to properly restore a hand-beaded dress.

'I am saving the Nica Riccis and many others I have of the period and will keep them for the grandchildren. As for the others — now that I have had my fun, it is time to share them with the world.'

PICTURES: TED BLACKBROW

By the time we arrived at the hotel a hair and make-up artist had arrived, and we gleefully got to work. The girl was extremely nervous but stunning; she looked brilliant in the dresses and coats and really made them come alive. I used every corner of the suite and every stick of furniture to try to make the outfits fit the different ages, from 1920 to 1968, and by the time we were finished I was satisfied with the results.

That evening we dined with Mme Vaudoyer in the hotel. I had been warned she would not be photographed, but after some outrageous flirting at the table, she allowed me some profile shots.

Considering the circumstances I was very pleased with the spread in the *Daily Mail*. I sent the model a set of prints, and I believe she had a successful career in Paris.

Anarchy on Westminster Bridge

On November 26th 1988 I witnessed scenes I had never expected to see in Central London. There had been an organised protest by students from all over the UK against the government's decision to levy charges for university education. Starting in the morning they had formed on the Embankment, marched past the Houses of Parliament and congregated on the south side of Westminster Bridge. Their efforts to approach the Houses of Parliament were frustrated by a large assignment of foot and mounted police.

I was ordered to go and watch over the proceedings just after lunch; it was a wet and gloomy day. I decided on a minimum of equipment – two Nikon bodies, a wide angle and an 80/200 zoom lens, and a pocket of film. I set off on what I thought would be a waste of time.

When I emerged from the tube at Westminster Station the noise from the far side of the bridge quickly made me realise I had underestimated the troubles. About a thousand students were screaming insults at the lines of police blocking the bridge. I worked my way through the police lines and joined the ranks of students as they tried to rally themselves into some useful action. Behind the line of mounted police officers it was possible to make out the light at the top of Big Ben; this showed the House was in session.

I climbed on top of a bus shelter to get some height, and the scene in front of me was amazing. A solid band of students was trying hard to make a breach in the wall of police officers facing them, and behind them was the panorama of Parliament. I stayed up there for about ten minutes, but then a couple of students identified me as a member of the 'fascist press' and started to make aggressive noises, so I decided to make my escape and work nearer the police lines.

As I got to the point where the two sides faced each other a group of students tried to charge the police line, and a young

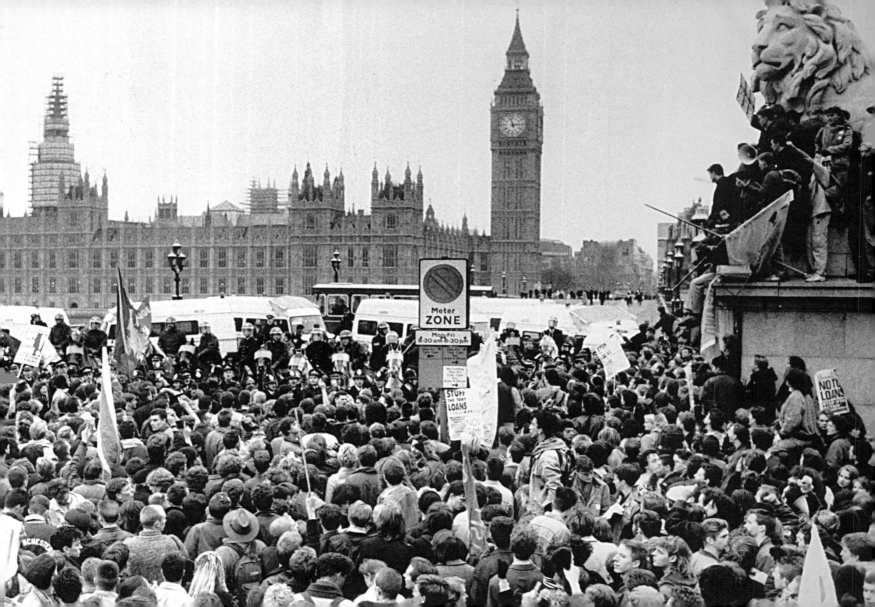

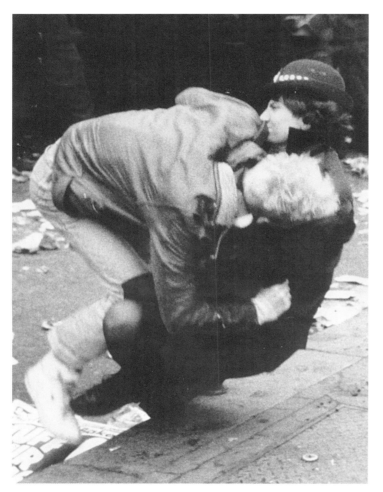
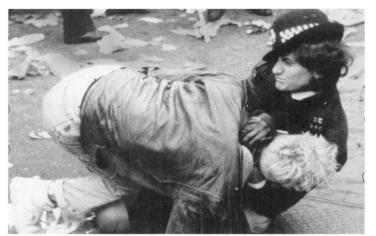
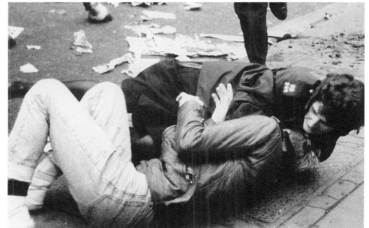

woman PC brought a demonstrator down with a perfect rugby tackle right in front of me; I managed a sequence as they rolled in the gutter.

The stand-off had lasted several hours and I was running out of light and film. I didn't have a flash with me as I had decided the story was all about the location. I decided to go back to the office as the mounted police were still standing in the spot they had been when I arrived. As I drew alongside them they charged; I took a chance on the exposures and apart from some movement I had a useable result. The students parted before the horses with no injuries, so I got away with it.

My pictures covered the paper, and I received a thank you letter from Paul Dacre, the editor that day. He claimed we had the best coverage of all of Fleet Street, and I wasn't going to argue.

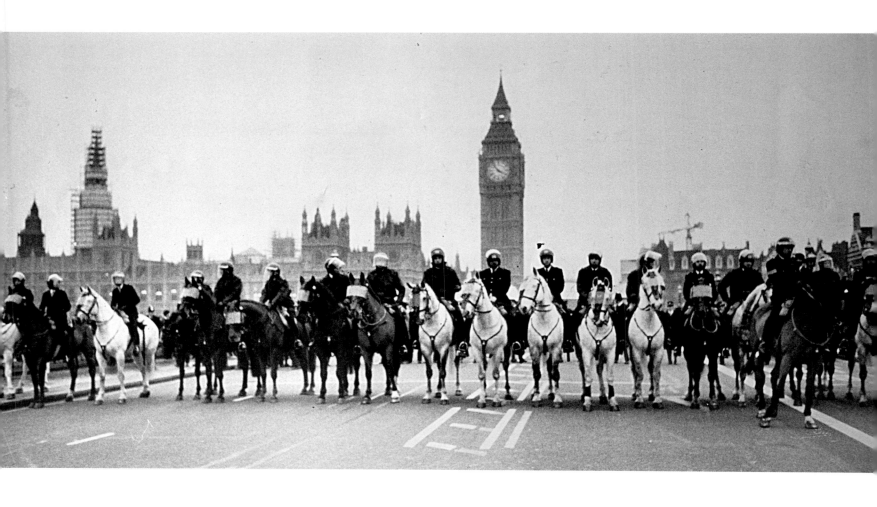

Eddie the Eagle

"With his thick glasses, broad West Country accent, ragged ski suit with a patch on his backside, he looks more like a hero from a Benny Hill song than a *Boy's Own* adventurer."

These were the words of my colleague William Davies in a full page piece we did on Michael "Eddie" Edwards in 1986. Eddie had written to David English to tell him he would be in St Moritz in December, training with the East German ski jump team, and that he intended to represent the UK at the Calgary Olympics in early 1988. William and I were flown out post-haste to find this phenomenon.

We found him at the top of the practice jump, after following a series of directions laughed at us from members of the ski jump fraternity, preparing for another flight. The first thing he did after we had shaken hands was to turn, bend over and display a huge denim patch where his ski suit had split. This suit had been a gift from the West German team, his helmet a gift from the Italians, his skis from the Austrians, and on the day we arrived he had just been given a new pair of boots from the Austrian Ski Federation.

Eddie was a plasterer from Cheltenham who had worked hard on the normal ski disciplines, downhill and slalom, but it had all proved very expensive. He ran up a huge overdraft, so he switched to ski jumping, which doesn't need poles, and here he was announcing his Olympic dream.

He needed a pair of ventilating ski glasses as he said "as I snap on my ski goggles at the start of the run down, my real goggles steam up and sometimes I am blind on take-off." His stories of how he survived to compete around Europe were extremely funny: he'd spent a couple of nights in a lunatic asylum and literally lived hand to mouth.

Fast forward 16 months and I flew out to Calgary to cover the Winter Olympics and whose name do I see on the official British team list... yes, Eddie Edwards; he had made it. I went up to the ski jump camp to renew our acquaintanceship

and take some pictures for the paper. Eddie was a small fish in a big pond, and over lunch he asked my advice about a small offer of sponsorship he had received from a printers in Cheltenham. I advised him to wait. He had achieved his ambition and was about to represent his country in one of the most dangerous events of the games; depending on his performance he might get a better offer. Words of wisdom as it turned out.

Then disaster hit the games. Calgary was being driven by winds from the west instead of the north; this meant a change in temperature of nearly 15 degrees, and the snow and ice began to melt. The games were stopped to await colder temperatures, and all the teams were asked to provide a star for a press conference in the main press centre. Step up Fast Eddie as the *Mail* had christened him. At the start of the conference he had about 24 journalists talking to him as he gave out his anecdotal stories of how short a career he had had

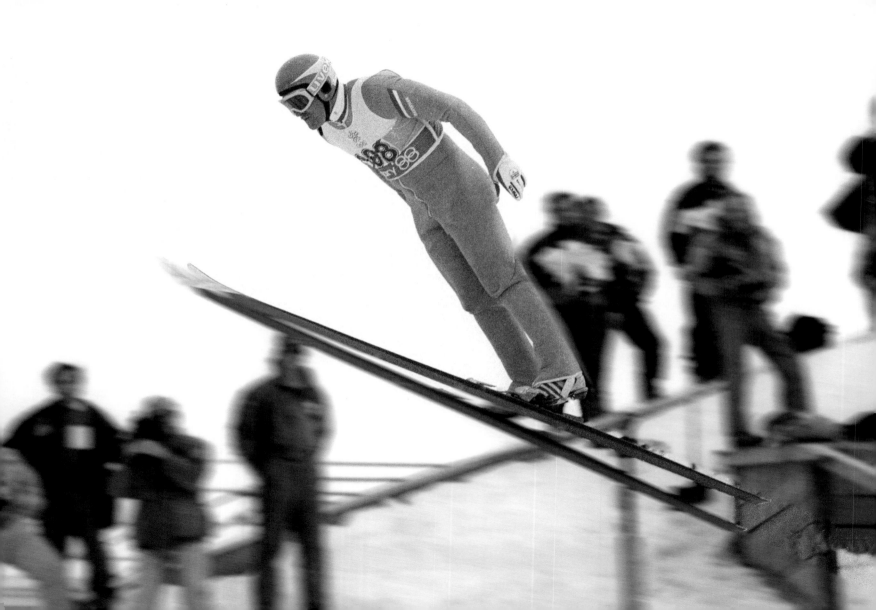

in ski jumping, his borrowed outfit, and staying in the lunatic asylum. The word swept the centre and by the time he finished a star had been born. As Ian Wooldridge wrote he was now known from Virginia to Vladivostok.

When the games restarted, all eyes were on Eddie for his first jump. The arena was packed, with TV and still cameras all scrambling for pictures of the new hero. When it came to his turn a huge screen at the bottom of the arena showed a close up of his face with his trademark pink glasses.

The announcer called for quiet as he prepared to jump, then a long pause. Again, she announced his name, but still he paused. Then she almost pleaded with him to jump and down he hurtled. As he flew through the air he wobbled, finally landed on two feet, just, and came to a halt at the bottom of the jump to a deafening roar from the crowd. He was in last place but in one piece, and judging from the noise and excitement anybody would have thought he had won the gold medal. Shortly after the jump Eddie received a large offer for his exclusive story from the *Daily Mail*, and I had to drop everything and look after him.

A lot of people decry what he did as a showman finding a loophole in the system to get access to the international exposure that gives ordinary people celebrity status. Eddie of course finished in last place; can anyone reading this remember who finished first? If you are still not sure about Eddie's motives, try going to the top of a ski jump and hurling yourself down its stomach-wrenching slope. Eddie did this time and time again.

The Olympic committee changed the rules after these games and put in what became known as the "Eddie the Eagle" rule, to stop anybody else following Eddie's path. Eddie tried unsuccessfully to compete at the next two Olympics, but this did not stop him becoming a celebrity. He has starred in numerous TV shows, advertising campaigns, and there is now even a film of his life story. He was Britain's first ever ski jumper and record holder. William Davies had christened him "Fast Eddie" in the 1986 tongue-in-cheek piece from St Moritz. It was the international press in Calgary who called him "Eddie the Eagle", and that name stuck with him.

The Eagle has flown!

Seoul Olympics

THE WINNING TEAM FOR THE BIG OCCASION

THE GAMES are here! And Sportsmail's Olympic team will bring you the action, drama, tears and glory from Seoul. Led by Sports Writer of the Year, Ian Wooldridge, our team of John Burton, Terry O'Connor, Carol Thatcher, David Williams and photographer Ted Blackbrow, will keep you informed and up to date throughout the Games. Kick off today with our 8-page Olympic Special starting on Page 19.

WOOLDRIDGE BURTON O'CONNOR THATCHER WILLIAMS BLACKBROW

This was an exciting world far removed from the side of a goal at Leyton Orient. I had been assigned to cover the Olympic Games in Seoul, my first summer Olympics. I was privileged to be working for a top team of writers: Ian Wooldridge, David Williams, John Burton, Terry O'Connor and Carole Thatcher, and I would be photographing the greatest athletes in the world.

I arrived in Seoul ten days before the opening ceremony to cover the build up to the games. Dave Williams, the *Daily Mail*'s chief news reporter, and I were acutely aware of what were perceived to be the two very real threats to the Games – the fear of terror strikes by agents from the communist north who police had warned had 'slipped in' to Seoul, and from radical students promising to force the cancellation of the Olympics. For months there had been clashes in South Korean cities, with images of tear gas, riot police and student mobs going round the world, but the real heartland of the radical movement was in Seoul's western suburbs and the vast, modern, grey Yonsei University Complex.

A day after witnessing first-hand some vicious street battles, Williams and I decided to provide *Daily Mail* readers with an insight into the students and their cause, while also finding out just who was orchestrating the daily violence. Casually dressed and one camera tucked away, we talked our way into Yonsei only to be confronted by a bizarre situation. Whilst the majority of students went about their normal routines, others had taken over classrooms and were actively preparing for their daily protest.

While Williams chatted to the student leaders, I was able to photograph what was taking place around us as students – some smoking – poured petrol into bottles and carefully fitted makeshift wicks into the necks creating hundreds of potentially deadly Molotov cocktails. It was effectively an armoury and bomb factory, with students cutting sharpened staves as they wrote banners calling for the cancellation of the games and reunification with the north. I worked quickly and quietly and recorded it all.

At about 2pm more than 1,000 radicals, many of them young women, poured onto the streets, with us following close behind. Outside the gates of the university the police waited in full armour and a standoff followed; on a six lane motorway, all hell broke loose.

I was perfectly positioned to record the mayhem as two well organised ranks of students ran forward and sent a hail of petrol bombs into the police lines, following up with a

frenzied charge with their sharpened staves. I photographed one policeman rolling around the floor with his uniform ablaze and another trying to 'snatch' one of the student leaders. Student charge was met by police counter charge forcing me to retreat with the students. Dozens of motorists were trapped in the middle during the hour long battle, but they were not targets and merely watched the drama unfold.

Amazingly, the riot ended as suddenly as it had begun; both sides stopped, turned round and retreated as if by agreement. It was a pattern we were to witness day after day in the lead up to the Olympics, and when the games started, the protests stopped. I was the only photographer present on that day, and my pictures were used all round the world.

When Woolers arrived in Seoul he brought with him a *Daily Mail* "Save the Seals" sweatshirt that Ginny Leng, our top equestrian star, had agreed to wear as a favour to David English, who was running a nationwide campaign.

I was not happy as I rode out the thirty miles or so to the equestrian arena, because the equestrian team and the UK press corps were at loggerheads over one of the women rider's domestic affairs. The story had broken as the team took off and the team management had tried hard to get the story out of the papers and concentrate on the Olympics. I was unsure of the welcome I would receive.

I arrived at the arena and was told that Ginny was in the practice ring working with her horse. I made my way into the

empty stand and took out a long lens to shoot some practice pictures. I had no sooner put the lens on the body when Ginny's horse hit the first of a triple jump, fell heavily and threw poor Ginny into the sand quite heavily. She lay still then, with the assistance team members, stood and limped out of the arena. The horse also appeared to be unhurt after a few moments.

The voice of the team manager boomed up at me from the scene, "I suppose you got all of that?" I waved my camera back at him and said, "It's my job, I hope they are both well."

I forgot all about the sweatshirt; the seals could save themselves as far as I was concerned. I shot back to the bus to the press centre to be interviewed by the full British press corps. Wooldridge allowed this as we had the exclusive pictures anyway. They were used over a page in London as a world exclusive. (I am pleased to say that Ginny and the horse recovered well and went on to win a medal!)

My next dealings with the equestrian team took place some days later as the games were coming to an end. The equestrian team were going for gold in the three day eventing and at the same time the British men's hockey team under Sean Kerly were playing a vital match to get into the final, some sixty miles across Seoul.

I did a deal with Joe Mann who was covering the games for the *Daily Telegraph*: he was keen to do the horses, I was happy to cover the hockey. So we agreed to meet back in the press centre after the events and swap some negatives.

The events on the equestrian field for the British team centred on two incidents. First, Captain Mark Phillips, Princess Anne's husband, had his horse go lame in the warm-up ring; he rode out of the ring and the Olympics. This put tremendous strain on the other three members of the team, as the marking was done by dropping the lowest team score. This meant to get anywhere all three had to perform to their very best. All went well with the first two riders, then the second disaster: the third rider fell off her horse and into the water at a difficult jump. She remounted and rode on, but we could no longer win gold.

Joe only had one good picture of the girl off her horse so we shared it and I gave him some Sean Kerly negatives in exchange. He hadn't seen Mark Phillips as he had been nowhere near the practice ring. I wandered round the press centre to all the foreign agencies, AP, UPI, etc. to see if they had anything I could "borrow" for the *Mail*. If I got a good picture of a foreign competitor that would be of no interest to my paper, I would always give the negatives to AP or UPI.

AP blew me out, they had nothing, but in the UPI office the editor was an old friend of mine from my UPI days, and when I asked him he exploded "Look what that silly b……has given me" and offered me his viewing screen and a lupe (viewing lens). The image showed the back of Captain Phillips and his horse leaving the ring. This was the moment our gold medal dreams evaporated. I tried not to appear too excited

and when he told me he was not issuing the picture, I asked if I could have it. He nodded and I shot off before he could change his mind.

I sent it to London along with the girl in the water and a selection of our victorious hockey team, then off for a hot shower, change of clothes, and a good night's sleep. The first two objectives I managed, but then the phone went from London. The editor loved my pictures and was preparing the page to take them, would I as soon as possible send the negatives either side of the picture of the girl in the water; he wanted to print a spread of them. I let the picture editor drone on then when he paused I said "no". I could hear the shock in his voice as he explained again this was a direct order from the editor (i.e. God).

Again I said "no" firmly and as he started to get angry and asked "why?" I explained they were taken on a very long lens. "What the f… has that got to do with it?" he yelled, and I said "I was sixty miles away when it happened". I also pointed out the equestrian and hockey events were running simultaneously. He quietened down very quickly and asked "How do I explain that to the editor?"

I suggested he show him the event schedule, the clash of the two events, and that he had the only picture in the world of Mark Phillips' withdrawal. He did, later he told me the editor laughed and made up his page.

Amid the frenzy of the Games, with all its travel between venues on car-choked roads, deadlines and late nights – we

were half a day ahead of London, meaning demands for more material were coming in during the hours we should have been sleeping – I was given an unexpected day off from Olympic work.

The *Mail*'s owner, Lord Rothermere, who was in Seoul for the Olympics, was hosting a dinner party for his journalists and photographers that had been organised by his companion Maiko Lee. During the magnificent Korean meal (we were all sitting flat on the floor) she approached me saying that she understood I was a fashion photographer as well as a sports specialist. This was true as I regularly worked around the world for the *Femail* department.

She asked if I could 'spare the time' to shoot a fashion spread of her in a spectacular traditional vintage Korean dress she had bought. I looked past her to Lord Rothermere and he was gently nodding, so I stepped back from the turmoil of the games to have a peaceful day photographing a lady known for her beauty.

I carried out a meticulous reconnaissance of suitable locations in the sprawling city to find the right setting and chose the classical gardens of one of Seoul's palaces. Trees, shrubs and flowers threw their shadows across the tiered lawns while providing privacy. It was ideal.

In the palace gardens, Miss Lee posed confidently and beautifully for the shoot, and we were both enjoying ourselves when she let out a squeal of delight as she saw Lord

Rothermere crossing the lawns to join us. She ran over to him and enveloped him in her long scarf. They chatted happily, but I didn't photograph this, as I didn't know if he would want me to; after a few minutes though, I asked if they would like some pictures together. They both said yes, and the result was a beautiful collection of pictures.

I gratefully accepted their offer of refreshments (it was a real scorcher that day) then hurried off to the main press buildings to oversee the processing and printing of my work, refusing to let the films out of my sight for a moment.

That evening the team was invited to another dinner, and when I arrived with Woolridge, we were able to present the pictures and negatives, gift wrapped to Miss Lee. To my huge relief, after immediately breaking open the parcel, both she and Lord Rothermere expressed delight with the pictures, passing them all round the table. That shoot was very personal for Lord Rothermere and Miss Lee, so I wanted them to have all of the prints and negatives, but one of the pictures accidently stayed in my camera case so that I could always prove I shot them. It's a classic of an English Lord and a Korean beauty.

When I flew out to Seoul such a fashion shoot could not have been further from my mind, but it remains one of the highlights of that remarkable trip.

Then the Olympics exploded! Ben Johnson, the young Canadian sprinter who had smashed the Olympic 100 metres

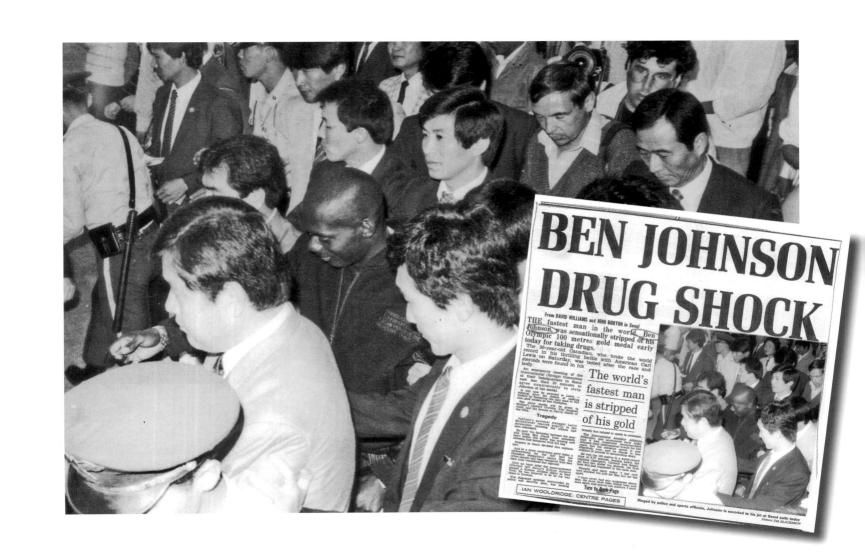

BEN JOHNSON DRUG SHOCK

From DAVID WILLIAMS and JOHN BURTON in Seoul

THE fastest man in the world, Ben Johnson, was sensationally stripped of his Olympic 100 metres gold medal early today for taking drugs.

The 26-year-old Canadian, who broke the world record in his thrilling battle with American Carl Lewis on Saturday, was tested after the race and steroids were found in his body.

An emergency meeting of the International Olympic Committee at their headquarters in Seoul took less than 20 minutes to agree unanimously to strip Johnson of his medal.

It will now be awarded to Lewis and Johnson's time, recording the race in a world record of 9.79 seconds, will be wiped out. The gold medals at two Olympics will now go to Lewis.

The silver medal will be given to Britain's Linford Christie, 28, third and the bronze to American Calvin Smith of the USA.

Tragedy

Johnson's personal manager Larry Heidebrecht reacted angrily to the decision, claiming the athlete had been tricked.

He said: "On Saturday between the semi and finals, Ben drank from a can they provided. His bottle was missing and may have been tampered with but had been tampered with but had not been.

Experts in Seoul derided this explanation.

And at a press conference after the Games, the Canadian delegation claimed that the urine samples shown to them had been fully tampered with but rejected with bad grace.

Only an hour after the announcement Johnson left Seoul's Kimpo Airport for New York. As Korean Air Kimpo Airport in Toronto. He is on his way back to Toronto.

The disgraced sprinter, surrounded by police and security men, was smiling.

The world's fastest man is stripped of his gold

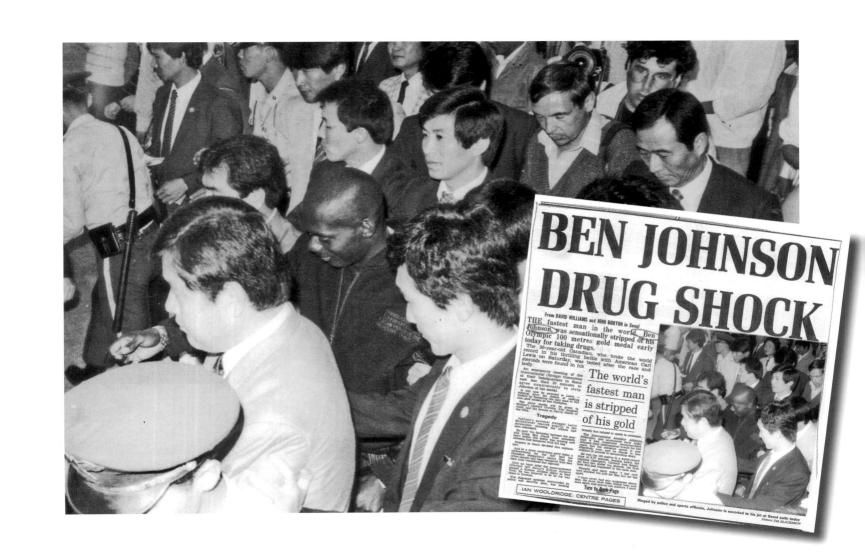

loudly but refused to speak to newsmen.

The International Amateur Athletics Federation also announced early today that Johnson had superseded immediately from international competition for two years, but the athletics banned is now effectively over, and the shock is now being felt throughout the world.

He was the 100 metres in a world record time of 9.79 seconds, a thrilling victory pitting sprint king Johnson against his arch rival Carl Lewis, the 1984 gold medal winner.

Christie and Smith did fine time that had been set at the same race.

Christie said early today: "I am very very shocked and happy for Ben.

"I have never had any suspicions about Ben, the tests have been carried out three again and proved him positive. I have

IAN WOOLDRIDGE: CENTRE PAGES

Ringed by police and sports officials, Johnson is escorted to his jet at Seoul early today
Picture: Ted BLACKBROW

Turn to Back Page

record and humbled Carl Lewis and Lynford Christie in doing so, was found to have been running on drugs. His title and medal were stripped from him, and he was to be sent home in disgrace. The news broke in the early hours Seoul time, and I had just finished a long, arduous day.

I decided not to join the heaving mass at the Athlete's Village, as it was obvious they would not let him be seen. I checked on times for planes flying out to USA, and the first one left at 9.30am the next morning. This was where I expected to find him. Early the next morning I hired a taxi, and with Ian Stewart the *Times* photographer drove out to the airport. We settled in with a cup of coffee and a short while later the doors at one end crashed open and a huge struggling mass of press, Olympic officials and government agents moved across the terminal towards the staff entrance to airside. There were about 30 of them, all pushing TV cameras and photographers out the way. It was impossible to see Johnson in the middle of the scrum.

Ian rushed into the fray, and I looked at where they were heading and jumped onto a brick garden display on the concourse. As they swept by I could just see Johnson's head in the middle of the throng. I shouted at the top of my voice but to no avail; he kept his head down and was gone. I got off two frames, then the whole mob went through the staff entrance to customs. It was 10am Seoul time, 11pm London time.

I grabbed Ian and we dashed back to the taxi and flew back to the press centre; as AP developed our films I phoned London, where it was fast approaching midnight, and told them what I had. They asked for a square image for the front, and this is what I sent. Ian didn't have a clear image of Johnson so I gave him my second negative. Poor Ian sent his the same way and the night operator in London stuck the print in a pigeon hole and went home for the night. Ian's description of what he would do to him when he got home cannot be printed. The *Mail* front page was a European exclusive of Johnson's departure.

After the Olympics finished I returned home. I had been operating for over thirty days, averaging 16 hours a day. I had lost over a stone in weight, and was due a long vacation. I went into the *Mail* offices to drop off some equipment and the picture desk made me stand on a chair to be presented with a "gold" (brass) medal they had made up which read on the front:

<div align="center">

XXIV OLYMPIAD

SEOUL 1988

DAILY MAIL

</div>

And on the reverse:

<div align="center">

GOLD

TED BLACKBROW

GT BRITAIN

MENS FINAL EDITION

</div>

I was touched by the gesture because it came from my peers. I still have it hanging in my office.

Ian Wooldridge

One of the great delights for me was working with Ian Wooldridge (Woolers), the greatest sports feature writer of his time. For nearly twenty years I worked with this incredible man, and through his genius met and photographed some incredible people and places.

While covering the 1988 Olympics in Seoul he suddenly announced to me that we were off to play a round of golf. I was puzzled, as golf did not figure in the Olympics in those days. Next morning, we drove up to the American defence lines on the South/North Korean divide line, picked up a US captain and drove to the Panmunjom peace village between the countries. If North Korea was going to disrupt the games, as they had been threatening to do for some weeks, this would be the battlefield. All the way up to the line, every sentry we passed sprang to attention and called out their motto, "stand alone" sir.

At the front line camp the commanding officer had ordered a field to be prepared with one hole and three tees of different distances to test his golfing skills. The green and hole were underneath an observation post manned by half a dozen heavily armed men, and one of the tees was golf impossibility: a tee on a bunker. All along the edge of the 'course' behind a heavily barbed-wire fence that stretched as far as the eye could see was 'out of bounds', as this was no man's land between the two enemies. We started to go round the 'course' in reverse order, playing tee three first as it was nearest the officer's mess and it was a stinking hot day. I treated it as a proper golf tournament, walking round past the armaments and watchtowers with the guards watching the North Koreans a few hundred yards away across no man's land. When we arrived at the first tee – eureka! It was positioned on top of a bunker in the defence line and clearly marked tee one alongside the 'Bunker 14 Delta Sector'.

I didn't play golf in those days but I had covered many tournaments, so I knew that here was probably the rarest

BUNKER #14
DELTA SECTOR

tee in the world. I took many shots of the players on the tee as they hit several balls each at the green 150 yards away. The colonel and his aide who were taking us round asked if I had everything I needed, and I explained that some fully armed troops coming out of the bunker as Woolers played off the tee would make the strangest golf picture ever. The aide was sent off at the double, and despite the heat, arrived back a few minutes later with a squad of six fully armed men. They proceeded to enter and emerge from the bunker at my bidding. I don't think they were thanking me in that heat, but what a picture! It ended up all over the back page.

Another golf encounter with Woolers was at the famous Wentworth Golf Club, where the club pro was Bernard Gallagher, an eight times Ryder Cup player and three times captain of the British team. Woolers had taken umbrage at some loony lefties who had come up with the idea of turning golf courses back into nature reserves and decided to declare war on them.

I arrived at Wentworth to find it was a ladies competition day, and all the ladies were walking about smiling. Enter the reason for their mirth: Bernard Gallagher dressed as a Roman Centurion and Woolers dressed as a modern army officer. I think Gallagher was having second thoughts, so I rushed them onto the first tee, got Gallagher to tee off, with Wooldridge keeping a close eye on the proceedings, and the crenelated Wentworth Clubhouse in the background. It has to be almost as funny as the sight of Eddie the Eagle's patched trousers.

I flew out to Bimini in the Bahamas with Ian and his delightful wife Sarah to cover four days fishing. Ian was to try three forms of the sport that drew lots of tourists to the island, then the *Daily Mail* was to organise a competition where the winners would be flown out to try to better his catch.

The trip started badly for me, as I was carrying a Hassleblad wire machine that could ping my pictures back to London (in theory). We disembarked from the flying boat that had brought us from Miami, entered the very small customs hut, and I was told by a huge customs officer who looked like Idi Amin's twin brother that as I did not have an import licence for all of my equipment, he was confiscating the lot! He dragged it over the counter and proceeded to stuff it into a large cupboard, muttering about a 'local' import tax that I could pay in cash. I ignored him as I objected to carrying the bloody thing in the first place; I was a photographer not a porter.

I jumped into a cab and hot-footed it to the hotel, where a quick call to London had the office angrily ringing Nassau. I joined Woolers for a G&T on the terrace and we waited for about an hour before laughing at the huge customs officer carefully unloading all my equipment in the afternoon heat. I forgot to tip him, what a shame!

The next day we went shark fishing, and Woolers hooked a large fish very quickly. As he fought with his catch the skipper of the boat, a large coloured gentleman, did everything he could to help within the rules. After about 90 minutes a large hammerhead shark appeared angrily on the side of the boat, thrashing and lashing trying to get free. I think Woolers would have liked to have obliged (he could see an angry reaction from some *Daily Mail* readers), but the skipper was having none of it. The 13ft, 413lb beast was tied to the side and dragged into the harbour. Here a line of local women and children awaited the carving up of the fish, and after photographing Woolers with his prize, they all went home happy. The *Daily Mail* never did run the competition.

In the early nineties Woolers started off on a round the world sporting extravaganza. He started in the New Forest covering a home match at his boyhood football club, Basham FC; he had reported on this club for his first paper in Bournemouth, so it really was a trip back in time for him.

The next day I flew with him to St Moritz to write a piece about the Cresta Run, a terror inducing, bone shuddering, ride down a sheer ice covered toboggan run – one of his sporting passions.

He then left to fly to the Far East and I returned to London, as the cost of us both travelling would have been prohibitive. There were all sorts of problems with the freelance photographers the desk hired for him in Hong Kong, Japan etc., so when he left Australia on his return journey, I was flown out to Hawaii to join him. I cried all the way to the airport!

He had arranged to write a feature on an English couple who raised and trained polo ponies. Then he wanted a second

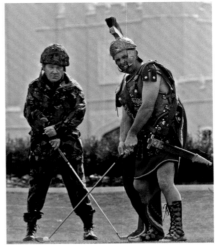

(Far left) Flying over England
(Left) Woolers and
Gallagher guard the course
(Below) The picture that
fooled his mother, foot on the
Duke's table

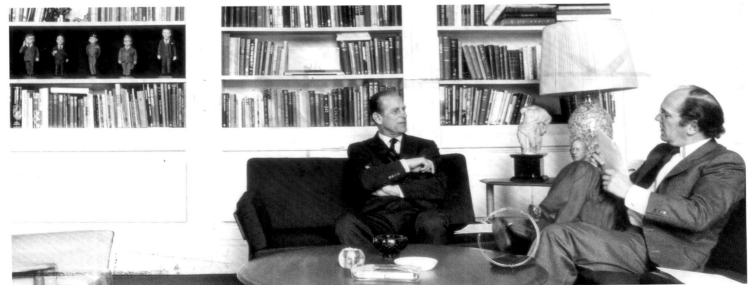

piece but couldn't decide what to write about; I suggested a flight over the Pearl Harbour bombing run that the Japanese had used in WWII. An in-flight magazine I had read coming in advertised a small USA company that flew a WWII open cockpit two seater over the run. He loved the idea and we booked it; all I had to do was illustrate it.

I had a long talk with the young American pilot and he agreed to fly the plane with one hand as they finished the run onto 'Battleship Alley'; just as he pulled back he was to call Woolers on the radio, and get him to turn his head hard right. I didn't have any camera mounts with me so this arrangement would have to do. I was hopeful, but not really expecting success; however, when I developed the film there was Woolers looking like Biggles as he flew over the shrine of the USS *Arizona*. Perfect.

Every year Woolers was invited to the apartment of Prince Phillip, the Duke of Edinburgh, inside Buckingham Palace to write a piece about the Prince's favourite sport: horse and carriage eventing. Woolers had always asked to have a photographer with him and had always been refused, but this particular year the Duke said yes, so I was in. I was to be allowed to photograph the handshake, then one minute (!) of the interview, then leave. This arrangement was further complicated by David English insisting that I photograph as much of the apartment as possible, as he wanted to know what made the Duke tick.

I walked in with Woolers, shook hands with the Duke, photographed their handshake, then asked them to sit wherever they would for the interview. I started shooting with a bounce flash as the room was a little dark; the Duke's aide stood waiting in the corner by the door.

I managed to stretch my one minute into two or three, attempting to make the scene interesting, but try as I might the pair sat in quiet conversation until the Duke suddenly announced "I think you have enough". I carried on snapping as I tried to get a better shot, whereupon he almost shouted at me "I think you have enough". I hastily packed my bag and followed the aide down the corridor.

As we walked silently down the carpeted corridor, his aide said "You have upset him you know". I simply said "He has upset me. I am a professional doing a job in a room I had never been in before; to give me one minute was a bit of an insult. If my name had been Litchfield would I have been given just a minute?" We carried on walking then he said "If you had asked that question as we went in, you wouldn't have been allowed in." I was never invited back!

The next morning my telephone rang quite early. It was Woolers, foaming at the mouth because his mother had seen the piece in the paper and given him an earful for putting his foot on the Duke's coffee table. He had only been crossing his legs, but that was what it looked like. I said sorry, but I had not picked the picture, so we had both put our foot in it.

Snooker in the desert

I was sitting on an Emirates jumbo on the way to Dubai when Ian Wooldridge explained the picture he wanted me to organise. It was to go with a feature he was writing about the ridiculous situation taking place in the Persian Gulf. In the north, Saddam Hussein had invaded Kuwait, and the USA, UK and other UN forces were joining up to eject him using the mightiest combined air and naval power the region had ever seen. Just a few hundred miles to the south however, a handful of very wealthy Arabs were watching the Dubai Classic in an air conditioned palace.

Ian wanted me to set up a snooker match in the desert between himself and the commentator John Pullman so that he could play with the absurdity of the situation. He had got the organisers of the Classic to agree to lend us one of the practice tables and remove the slate beds to make it lighter, but it still weighed over a ton. As much as I liked the idea, I told Ian that if he wanted a snooker battle in the desert, it should be between Steve Davies, the then number one, and Stephen Hendry, who was challenging him for the title. Woolers agreed, but I had to be the one to persuade Davies and Hendry.

I knew Steve Davies, and despite his "boring" tag he had a sense of humour; I put the idea to him and he went for it straight away. Stephen Hendry was a different kettle of fish; he didn't fancy standing in the desert heat in his playing gear, and only agreed after I promised to keep them out of the air conditioned limo for just two minutes.

The next day in a long cool limo, Woolers and I scoured the nearby desert roads for a spot where I could position the table so that the game would look like it was in the middle of the desert without showing any road. We found a suitable spot just up the road from a camel farm – game on!

The next morning I left the competition venue at 6am with a gang of 30 Arab workers, a snooker table less its

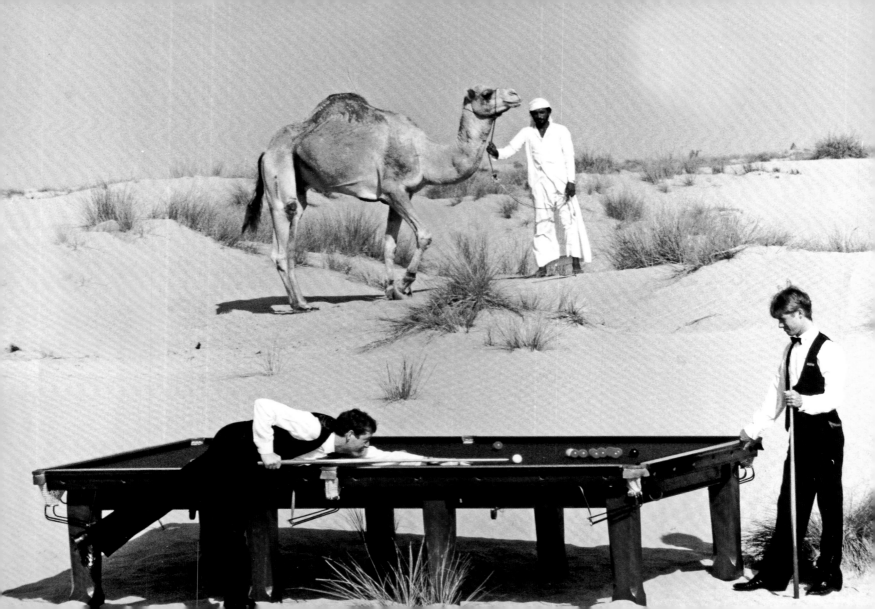

slates, and a young American roadie, and we sent off for the designated spot. The Arabs manhandled the table off our flat-bed truck and we hauled it onto my chosen spot, dusted it off, and then tried to place the balls. It didn't matter how many bricks, stones or pieces of wood we placed under the table, the balls just kept rolling into the pockets. After an hour or so of this I was ready to give up; we had all sweated buckets, the heat was building by the minute, and the players and Woolers were due to arrive shortly. Then it hit me! The young American was chewing gum, and had several packets in his pockets. Ten minutes of frantic chewing later and we had enough to stick all the main balls down. I had sent a young Arab to the farm to hire a camel to stand and be the only audience to the match; he arrived just before the limo and all was set.

I went to the limo and asked the two players to take turns appearing to play a ball or stand watching while I took some wide angle shots by the table. I then scooted to a pair of steps I had brought for a telephoto view. Steve Davies went to hit the white; I screamed at him and showed them the chewing gum. I got the wide angle shots off quickly, ran across the road and up the ladder to see the camel's bum staring me in the face. I yelled at the Arab holding him with every swear word I knew and slowly the camel turned, the motor drive whirled and job done; the players were back in the limo in under two minutes.

The picture was used as a full page spread, and the *Mail* earned a fortune from its syndication. Woolers thought the camel was a bit OTT, but I told him the whole picture was OTT!

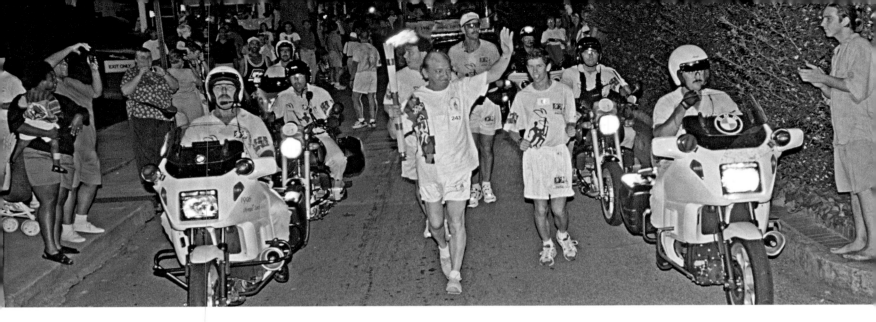

Woolers had a need to try anything that the athletes could do and in Atlanta for the 1996 Olympic games he nearly went too far. He volunteered to carry the olympic torch as part of the official relay. His leg was in the early hours of the morning, in downtown Atlanta and I had to record the event. I didn't want just running pictures, as he was to be accompanied by motorcycle cops and officials, and hopefully cheering crowds.

I positioned myself on the vehicle preceding him through the streets, set a very low shutter speed and lit Woolers with a flash. Apart from a little movement it worked well and you could see it was the real thing.

As soon as his run was over, we jumped into a waiting cab and rushed back to the olympic village for a long cool shower and some refreshments. He had done it! He was several years older than me and I could not have run that distance in those conditions. He was very special.

After he died in 2007 I attended his memorial service in the Guards Chapel in London. I made it to the chapel via the Horseguards Parade where I enjoyed the pomp and ceremony of the Changing of the Guard that he so loved. I could almost feel him in the crowd.

Introduction – The 90s

Throughout the nineties I think I must have walked with a permanent smile on my face. I had my dream job, and when I considered the excitement of that first game at Leyton Orient some thirty years before, I was amazed that I was still just as excited now that I was covering all the best sport in the world. At the start of each month I would go through the diary of what was needed for sport and either elect to cover it myself or leave it to the agencies. Sheer bliss, so much so that I didn't take a day off for the first few months while everybody got used to the idea of having a sports photographer.

I elected to cover sport all over the UK. We had staff men in Manchester and Birmingham, but when the biggest stories were on those patches, I pulled rank. Football in Manchester, Liverpool, Newcastle, and all over the Midlands, rugby in Scotland, Ireland and at Twickenham, Ryder Cups in the UK and US, Olympic Games, Commonwealth Games,

World Cup football: you name it, I did it. I now had time and access to work with some of our top stars: Sharon Davies, Daley Thompson, Steve Backley, Fatima Whitbread and many others. At golf events it was a pleasure to work with the world's top names, and I am sure I was a bore at family parties when friends or relatives wanted to talk about one particular star.

Just travelling to the venues was exciting. The accepted mode of travel for football trips was for the F.A. or the club to hire a plane and fill the front with the club's staff and players and then let the press buy tickets at the back. This could make for uncomfortable travelling physically, but had definite advantages at airports where, not wanting the teams to be delayed, we were swept through. It had other incredible bonuses too. In the early 1990s on a flight to somewhere in Eastern Europe I sat next to Bobby Moore, one of my all-time football heroes, and just after take-off we were joined by

Trevor Brooking. I will never forget that flight; I was in total awe of both men.

On these football trips we carried the portable wire machines and darkrooms and did all the work ourselves, but on longer trips such as, Olympics, Ryder Cups, etc., the paper would hire one of the agencies to process and wire for me. Carrying the equipment was physically very demanding, and I was always arriving at the venue or home totally wacked out. On one occasion at Heathrow it created a stand-off between me and one of Her Majesty's customs officers.

I was tired and traumatised by a long trip that had gone wrong, and as I walked through the 'nothing to declare' channel on my return I was pulled up by a young customs officer in a shiny new uniform. He had trouble written all over him. He demanded my manifest for all the equipment I was carrying, and I produced my press pass and explained I had left in a hurry so I didn't have one. He was not amused and started to inform me of the dreaded consequences for such a light-hearted approach to customs law. How did he know all the equipment was mine? I told him I couldn't prove it was, but that didn't matter because it all belonged to the *Daily Mail*. I said "Give me a receipt for every piece and I will leave it with you". I was exhausted and just needed a bed.

He went off for advice and returned with a senior officer, who started to go through the same warnings as his junior had done and told me what he thought of my attitude. I told him I didn't care, I intended to leave all the equipment with them and go home.

It was of course a bluff, but it worked. They could see how much paperwork they would have to fill in, and it was late, so surprise surprise on this occasion they would simply file a complaint to the *Daily Mail* and I could go. Next day the managing editor called me in and told me in future I had to carry a manifest for all my equipment on a trip. I explained this would be impossible if as usual they wanted me to move fast, so we agreed to forget it.

On one of these trips to Moscow we were there for three days, and on visits to Red Square found street traders selling Russian army hats and tins of Beluga caviar for $10 a tin. We all stocked up at these crazy prices and when we arrived at the airport late after the match, I grabbed my mate Albert Cooper of the *Mirror* and told him to wait with me. Between us we had some 10 heavy cases of clothes, lenses, cameras, wire machines, and of course tins of caviar and Russian army hats.

By the time we entered the customs hall, the team and officials had gone past a large sign saying trade in hats and caviar was illegal, and to leave your ill-gotten gains here. There was quite a pile. We were the last two in the party, and the airport was full of drunken England fans leaving on other planes. I pushed forward my camera bag full of bodies and lenses, and my wire machine. Albert did the same and the

officer in charge of the customs officials said something in Russian and we were waved through.

When we got on the plane laughing at our 'coup' we were followed on board by the customs officer and one of his men, who proceeded to re-sell the caviar and hats to the people who had surrendered them. We didn't stop laughing all the way back.

The *Mail* had employed a young photographer as my number two because of the growth in the number of pages we covered in the paper. He was desperately keen to win the Sports Photographer of the Year award, a competition I had never entered as it was judged on one picture only, and I thought this ridiculous. I spoke to the sports editor and he said the prestige of winning would be weighed up in assigning us to events. I decided to win it that year, and told him so; he of course did not believe I could do it.

A couple of years earlier I had produced a picture taken at Ponds Forge, Sheffield, of our then number one female diver plunging into the water, taken through a window below the water level. The effect of the force of the water on her skin had produced a 'Michelin Man' effect, and a lot of interest among our readers. I had tried to catch the instant she split the water, body half in and half out of the surface, but no matter what I tried I could not do it, so the idea had been placed on the back burner.

Now I attacked the idea with a vengeance. A trip to my granddaughter's school showed me a work she had produced

in a small aquarium, with a volcano made of plasticine coming off the bottom and splitting the water: this was it! I purchased a small aquarium, built a metal brace to hold it steady, and weighted it so that the lens would split the surface line when the camera was inserted onto a sponge base inside. I then went off to try it on the same granddaughter, who was my model for these trials, and it worked well.

Then I contacted the national diving team who were preparing for the Atlanta Olympics, and they allowed me to photograph Leslie Ward, our number one diver for the games. I explained after she had stopped laughing at my Heath Robinson contraption that I just wanted her to drop off the end and enter the water as cleanly as possible. With a release line to the camera and a large flash in my hand I would do the rest.

I exposed a whole roll of film, changing the timing fractionally each time, then removed the film and took Leslie out for a good lunch. As we passed Boots in the high street, I left the film for processing and a set of one hour prints. The results were spectacular, and this picture was the best of the bunch.

At the end of the year I walked off with the Sports Photographer of the Year title, and it won a couple of other small awards. I think I made my point.

Sharron Davies

I first met Sharron Davies in the mid-seventies. She had just won seven gold medals at the UK National Swimming Championships and I came up with the idea of copying the famous picture of Mark Spitz with his seven Olympic Golds in a 'V' round his neck. The idea worked well and I became friendly with Sharron and her family, often driving down to their home in Plymouth for pictures.

While I was covering the Seoul Olympics in 1988, I invited Sharron and another friend, Mary Peters, to lunch (they were both working as TV presenters for the games). Over a disgusting plate of kimshee, the garlic infused national dish, Sharron dropped her bombshell. She wanted to swim in one more Olympic games, and had decided to get back to her best and try for Barcelona 1992.

She swore us both to secrecy, as she didn't intend to announce anything until she could swim the qualifying times. I agreed as long as she would let me break the news in the

Daily Mail first – she agreed. I wasn't sure that a comeback was right for her, but she had been cheated out of gold in Moscow by an East German on drugs, so I could understand her desire.

A few months later she rang me to tell me that the *Mail on Sunday* had found out her secret and were preparing a large exclusive for that weekend; as this paper was part of our stable she felt this would be OK. It was a Friday and I begged her to meet me in the pool she was using for training and let me do a few pictures. We came out with the story and a picture on the Saturday morning, and the *Mail on Sunday* promptly dropped the spread.

Sharron was not at all happy as she had sponsors to keep sweet and they had wanted the *Mail on Sunday* spread. I offered to go down the following week and get something different for the new weekly sports magazine we were running in the *Daily Mail*. It's easy to say 'something different', but I

had shot just about every type of picture of Sharron over the years, and providing something new was proving difficult. We tried the usual on the water, under the water, I even tried to get the moment she walked on water before sinking, but nothing was 'different'. I tried some strong portraits with her head submerged to the eyes. This looked good, but with other swimmers using the pool I couldn't get a straight water line. I needed an empty pool, so she led me round to the back of the complex to an 18 inch deep child's paddling pool. She lay flat in the water, I lit with a straight flash, and there was her head and a perfect reflection on the surface.

I took the pictures back to Fleet Street and it made the cover of the *Sport Mail* magazine. I was happy, Sharron was happy and her sponsors Speedo were ecstatic. Job Done!

Snowflake

It was 1991, and the Athletics Federation was holding a European Athletics meeting in Barcelona to test the stadiums and infrastructure for the Olympics the following year. The *Mail* sports editor decided to save a few bob and not send a photographer. On the night before the meeting was due to start one of the British team disgraced himself in a dockside strip club by committing a sex act on stage while wearing his uniform; no photographers were present, and the editor screamed to know why. I flew out on the next flight.

Of course by the time I arrived it was all over bar the shouting. The athlete had been sent home in disgrace, and I was able to settle down to a good weekend of athletics.

On the Monday all the journalists, TV crews and teams were leaving for home, but because I had been sent so late my only guaranteed seat was late in the evening. I had a choice to sit at the airport and hope for a seat on an earlier flight, or enjoy the delights of Barcelona at the *Daily Mail*'s expense; there are no prizes for guessing which option I chose!

I decided on an early start and took a taxi to Barcelona Zoo, where the star attraction was an albino gorilla called Snowflake. He had been adopted as a symbol of the city and his picture was everywhere, but I wanted to try to get a picture of him against the sunlight so that his white fur would really stand out. I arrived at the staff gate of the zoo at 8am although it did not open till 10am. I hung about until a shifty looking staff member arrived; I waved my press pass, my athletics pass and a £20 pound note under his nose and in halting English/Spanish asked to be allowed in to see Snowflake. I think it was my Spanish Athletics pass which influenced him most, although the £20 note disappeared very fast indeed.

He took me round to the gorilla enclosure, went and got some vegetables and fruit and enticed Snowflake and his mates out into the morning sunlight. This animal was

incredible. He prowled up and down his enclosure glaring at me, and as he walked through a patch of backlit sunshine, I got this image; it was everything I wanted. I was so pleased I gave the keeper another drink, then left for a stroll down Las Ramblas and a leisurely lunch of fish and wine at an outdoor restaurant before heading back to London.

One of the pictures was used by the *Mail on Sunday* magazine for which I received a handsome fee; not bad for a day's work seeing as how the paper had paid for it!

I was very sorry when Snowflake died some years later, he really was magnificent.

Seve Ballesteros

The Ryder Cup at Kiawah Island, South Carolina was my first, and I was very excited to be among the best golfers in the world, although this match was to prove quite a challenge. Kiawah Island is a millionaire's playground, set on the shores of the Atlantic on land reclaimed from swamps. It is covered in small lakes all with signs saying "Beware of Alligators". For the first few days every golfer was photographed walking past these signs, until we and the office in London were fed up with them.

I decided to see if it was possible to take the idea further, and went to the head groundsman of the club to ask the whereabouts of the biggest alligator left on the course, and the likelihood of it showing itself with people nearby. The alligators were quite young as the older, bigger specimens had been removed, but the biggest one left on the course was in a lake under the 9th tee.

The teams were still practising, so next day I waited by the lake and sure enough, the beast appeared, but as the first

group of players arrived, it sank below the surface. I moved further back from the lake to where I could cover the tee and half the lake on a 300mm lens; this had a foreshortening effect which would keep the alligator and the players as large images.

The next day I returned to the spot early and prayed that if the alligator gave me the chance it would be with a European player, not some unknown American. I kept walking to the course to get pictures for that day's paper, then returned to my spot. By tea time I had had enough, and I needed to move some pictures to London. As I prepared to leave Seve Ballesteros and his partner walked onto the tee and the beast rose from the lake and swam across before disappearing again. I got a perfect picture of Seve swinging as the beast swam by.

I went back to the press tent and wired the picture to London. The agency who were processing my films for me had spread the word of what I had, and a crowd gathered to look at the image. Soon the writers were filing stories of Seve's narrow escape from the "Jaws of Death". My world exclusive image earned the paper a fortune in syndication fees all round the world.

The other picture of Seve shows him on a dreadful rain swept day in Gleneagles, where the Scottish Open was being held up by the torrential rain; everything was flooded. The usual formula to give the writers something to fill the pages was a press conference of any of the best golfers the sponsors could manage. On this day it was Seve. After the conference we grabbed him and asked him to stare out of the rain soaked window for a picture. He agreed and put on his Paddington-style rain hat and looked out at the cameras. He wasn't near enough to the glass, so I did a deal with my old mate Albert Cooper – I went in with Seve and talked him closer to the window, and Albert dropped me a couple of negatives. Job done.

Steve Backley

Steve Backley is the greatest UK male javelin thrower of all time. I worked with him in his build-up to the 1992 Barcelona Olympics, and when the paper decided to carry a large feature, I set about finding a good picture to illustrate it. Like any athlete you have worked with over time, almost every idea had been tried, so I rang Steve and asked if he would give me time to try something different.

He was based in Loughborough and I went up armed with a couple of large black sheets, and a flash that could be set to 'synchro' mode i.e. lots of flashes in one frame. He had arranged for us to have a large empty room in the college; I covered a wall with black sheets, set the flash and camera up and away we went.

We didn't have the space for him to run up as normal, so I decided we would concentrate on his arm, head and torso for a powerful image. It didn't work. His arm kept covering his face and the flash images merged to make a mess of the main part of the picture.

So we switched the flash to a position in front of him and I fired it with a remote release. The camera I set for a time exposure and fired with the other hand. At last we had a working picture that we could only improve on.

But I had trouble making the picture ready for the paper. The image was covered with bits of equipment or wall that had caught the flash and needed to be obliterated. I was working with a rather stroppy printer and it took a lot of effort to produce a useable print. It was used full page in the paper and I thought no more about it until I resurrected the image for this book.

Now I have Photoshop, I can spend happy hours working on my images; the image here, a colour photo with the colour removed, is what I had in mind at that time.

Thank God for digital and Photoshop!

Linford Christie

The highlight of any Olympic Games is the men's 100m final. In the 1992 Olympics in Barcelona it was held on the Saturday morning of the first week, but this was of no use to me as we didn't publish on the Sunday. If I wanted to get a picture in the paper that would hold for 48 hours, I needed something unusual. I worked my way round the final bend of the track to shoot the finish on a 300mm lens in the hope that this would be different or the celebrations of the winner would make a show.

The runners sprinted across the line, with Linford just winning. As they decelerated Linford took an amazing leap into the air, which from head on had no great impact, but with the rest of the field looking on at him and my 300mm lens foreshortening the distance between the runners the image was a winner! A brilliant example of being in the *wrong* place at the right time!

Tonya Harding

1994 was the first time the Winter and Summer Olympics had been held in separate years. The Winter Games were being held in Lillehammer, Norway, and I went out to cover Torvill and Dean's attempt to regain the gold medal they had won in 1984. The rules had been changed to allow professionals back into the competition, and they had taken advantage of this to perform.

I followed them every step of the way, but with a huge bias against them it was fairly obvious they would not win. The judges favoured two young Russian pairs, and Torvill and Dean finished with the bronze medal. They then headed home, so I rang London and asked permission to stay. The sports editor asked me to stay another day as Tonya Harding and Nancy Kerrigan were due to compete in the final of the ladies' singles figure skating the next day. I explained that as I hadn't requested a pass for this event, I would be lucky to get in, but I would try.

An ice rink is a perfect oval and at one end skaters sit and await their marks. It's known as the 'crying zone' and this is where every photographer wants to be. Here, it's possible to cover the skating and all the emotions at the end. The pass I managed to get placed me at the other end of the oval, next to the ice cleaning machine. I was not happy.

Tonya Harding's boyfriend had been convicted of an earlier attack on the USA number one skater Nancy Kerrigan. He had attacked her knees with an iron bar and Tonya was implicated in the attack. She was stripped of her national titles and banned from appearing in competition in the USA, but for some reason was allowed to skate in the Olympics.

The girls came out and warmed up on the ice, Harding and Kerrigan staying well apart, then the competition began. Harding skated out and proceeded to warm up. As she did so it was obvious all was not well; she kept feeling her right skate and leg, then stood with her back to the massed photographers

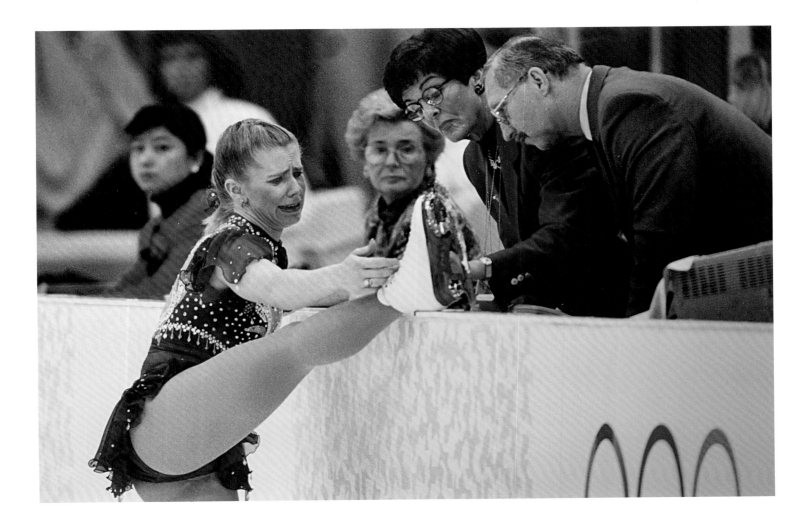

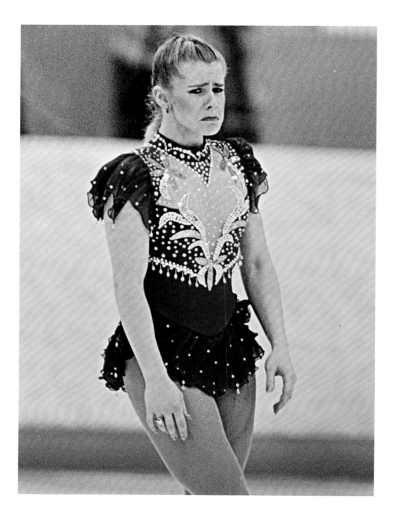

in the 'crying zone', her face a picture of sadness, trying to hold herself together. She skated to the judges' table, cocked up her right leg and showed them her skate was damaged; she was now in tears.

All of this was perfect for me; she kept her back on the main mass, but faced me throughout her ordeal. Another case of being in the wrong place at the right time! I would like to say I felt sorry for her but I didn't, and my mother's favourite saying kept running round my head: cheats never prosper. Kerrigan took the silver medal, and Harding won nothing.

Brian Lara

Brian Lara was the world's greatest batsman when he came to England in 1994 to play for Warwickshire. He was contracted by the *Daily Mail* to write an exclusive weekly column, and I was ordered to drop everything and be with him every day that he played that season; not a difficult task for a cricket lover. It was all going well; he was scoring lots of runs, and he even set a new world record at Edgbaston, but then came Taunton.

It was the third day of a dull, rain affected game played under gloomy overcast skies, and on this final day of the match the two captains had agreed for Somerset to go in and score a number of runs to some easy bowling, then Warwickshire would go in and chase this total to try to get a result. This was common practice at the time.

I think I was the only photographer in the ground, cursing my luck as the rain came and went. The light was awful and it was hard to concentrate on play. My camera with long lens on a heavy tripod was trained on Lara fielding in the slips. I covered the button with my finger on every ball just in case although Lara was showing complete indifference to the proceedings. Something about his movements caught my eye and I looked through the lens to see, in glorious close-up, Brian Lara using his mobile phone. I couldn't believe my eyes. This was after all a first-class county match, and he was even

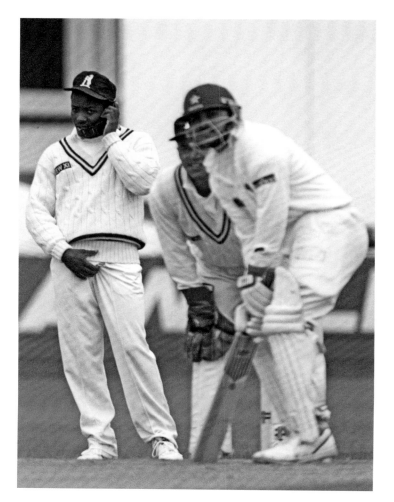

phoning as the batsman played a shot. I fired off a few shots with the phone to his ear, then he finished his call and started to field properly.

I rang the office for advice. This picture if published would have heavy repercussions for Lara. In the end the editor of the paper decided to publish and be damned!

The next day England cricket authorities and the Warwickshire Cricket Club came down on Lara like a ton of bricks; he was called in and severely reprimanded. When I next saw him, it was for the last time, as he blamed me for his troubles and wanted nothing more to do with me. At least he didn't tear up his *Daily Mail* contract!

Roger Bannister

Roger Bannister's four minute mile had a massive impact, not just on athletics, but on the whole world, still reeling from the Second World War.

It took another forty years for the Oxford v Cambridge annual athletics meeting to find another runner who could copy the performance on the Iffley Road track in Oxford. The great man himself was going to attend to watch the event. I joined a group of my colleagues at the track and we had to talk hard to persuade Bannister to stand just behind the finish line, with a stopwatch in his hand.

For all of the fame and adulation heaped on him, he was a retiring type who was happiest in his college. He was not happy about 'posing' for a picture, but in the end he agreed and we got him to stand just behind the finishing line, stopwatch in hand.

The race went to plan and the final picture of the young athlete striding across the line with his arms raised in triumph must have had a profound effect on Bannister – history had been repeated.

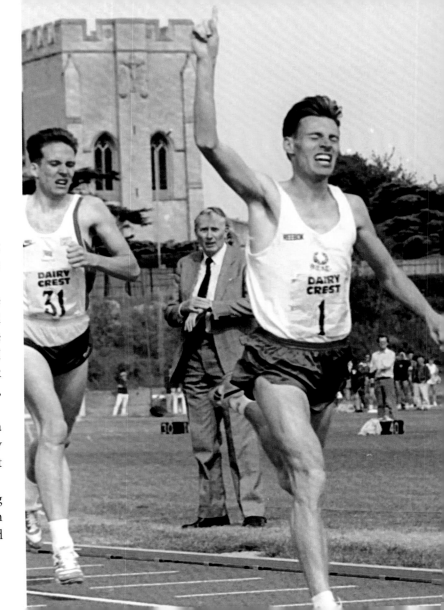

Jack Charlton

It was 1995, and I had gone to Liverpool to cover a European qualifying match between Holland and the Republic of Ireland. Ireland were managed by 'Big' Jack Charlton, one of the heroes of England's 1966 World Cup winning team. Charlton had announced that if Ireland lost this match and were therefore out of the European Championships he would retire.

The match was played in a packed stadium that was a sea of green, white and orange. It was a closer match than many had predicted as the strong Dutch team were hot favourites; in the end though their class told, and they won by two goals to nil.

The teams went off to salute their fans and did a lap of honour, then as the Irish trooped sadly off the park, Big Jack appeared and shook hands with each of them at the tunnel entrance. The Dutch also trooped off and the crowd began to leave, except for a small group of 500 or so Irish fans who stayed singing at one end. I sent my films back to be processed but instead of following I waited opposite the Irish fans who had

started calling for Big Jack. I just had a hunch that he would re-emerge to acknowledge them, and after about ten minutes I was proved right, as he appeared to thunderous applause and cheering and made his way onto the pitch about twenty yards in. He was carrying a Dutch flag and an Irish scarf he had been given, and was smoking his trademark small cigar.

He waved to the supporters and stood silently and watched as they sang his name, then the moment I had waited for: Big Jack, the steel-hearted defender of Leeds and England, famous for his tough attitude to the game and to life, wiped a tear from his eye. A sad, lonely, human figure.

The picture was splashed over the back page and at a press conference the next morning he was asked about this moment. He insisted he had not been in tears but was simply wiping a piece of dirt from his eye. I don't care what he said, I took the picture, and it showed one of the strongest men in football in tears.

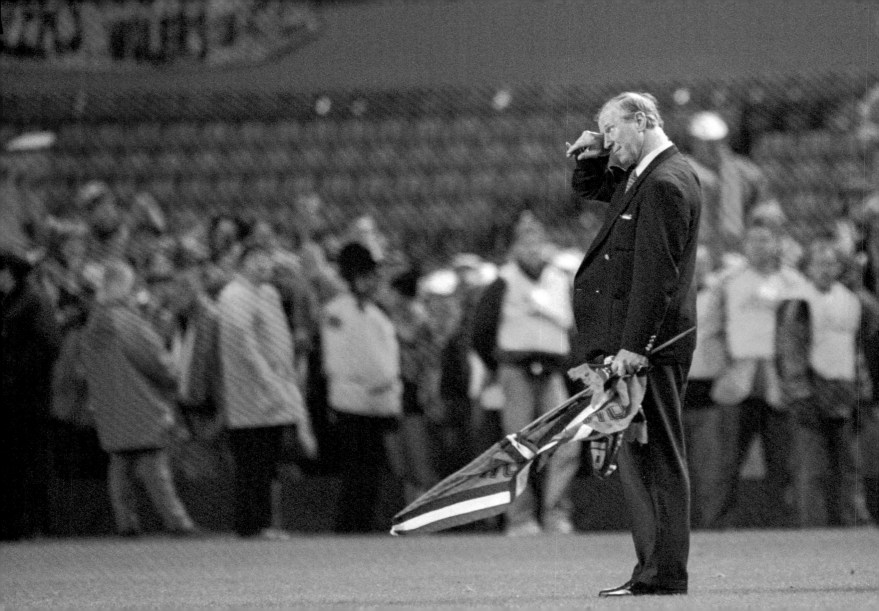

Paul Gascoigne

Whenever I think of Paul Gascoigne ("Gazza"), I remember a conversation I had with him in a hotel bar in Santander, Spain. The photographers were having a beer for the road when Gazza, still in his tracksuit, asked if he could join us. We bought him a beer and hid it amongst ours in case the FA officials looked in. We chatted about football in general and he told me his idol was "Hand of God" Diego Maradona, and how Maradona had bought all of his mates a Rolex watch: what did I think of that?! I told him if he wanted to repeat the gesture, we would all be his mates and the queue would stretch around the block!

The first of these pictures was taken on an England trip to Turkey. The training session was stopped twice for torrential rain, and as the players walked back to their bus Gazza suddenly dived into a deep muddy puddle and proceeded to cover himself in mud. Within a few seconds he was joined by Ian Wright, another comedian, and they set about mud

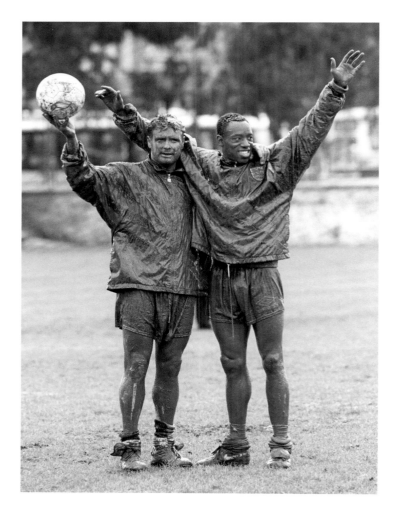

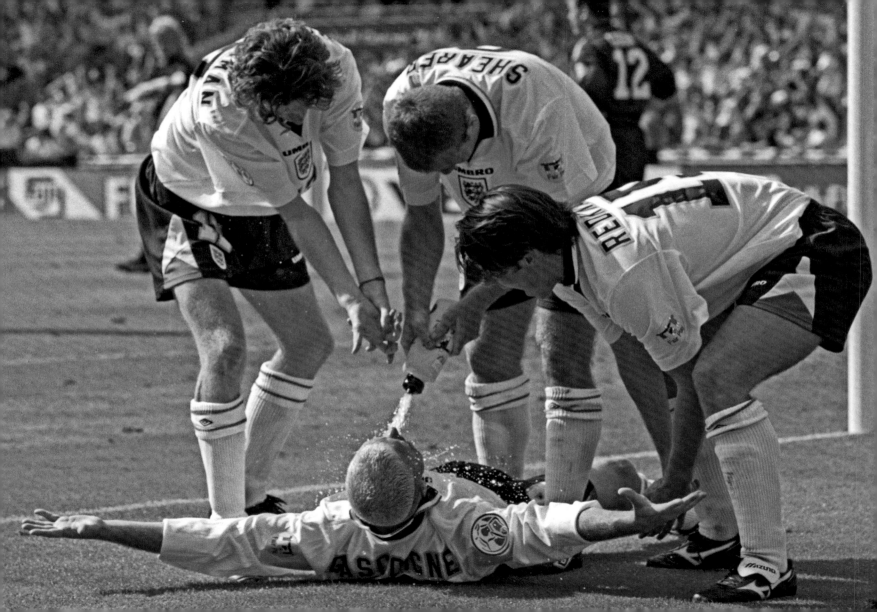

wrestling until they were both covered, then they stood and posed with a ball like they had just won the cup. The manager Gordon Taylor and his assistant Laurie McMenemy, stood laughing helplessly on the side of the pitch.

The facing photograph was taken at an England v Scotland European Qualifier at Wembley in 1996. A short time before this game Gazza had been photographed in a bar in the Far East that had a dentist's chair, where men sat back and had alcohol poured down their throats. The press slaughtered him for it and it was obviously on his mind when he scored a wonder goal against the Scots. He ran screaming towards me, fell flat on his back and allowed other players to recreate the dentist chair routine with orange juice.

The whole stadium erupted with the goal and the strange celebration; Gazza was a hero once again, but it didn't last.

Steve Redgrave

I have been asked many times who is the greatest sportsman I have ever photographed – Seb Coe, Carl Lewis, Maradona, Daley Thompson, and Roger Bannister spring to mind – but there can just be one answer: Steve Redgrave, the only athlete to ever win gold at five consecutive Olympics.

I first started working with Steve in the eighties when he joined up with Matthew Pinsent and formed the greatest rowing pair ever. I made several visits to their Leander Club at Henley, watching their incredibly tough training routines and going out on the river in their trainer's launch as they worked. The hours they spent in the gym at the club lifting weights, pulling ropes and rowing on machines were enough to make my head spin, and to think he had done this for twenty years by the end. I may have worshipped the man.

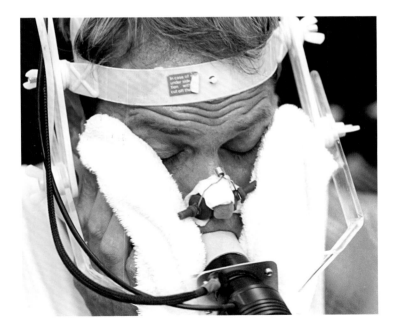

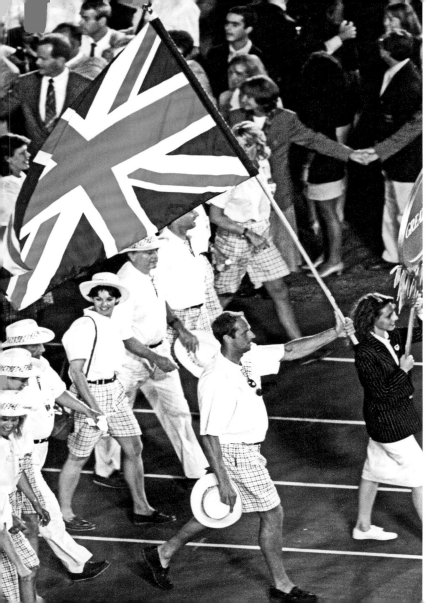

The first picture was taken in the British Olympic Medical Centre in North London. The boys had agreed to let me photograph them rowing to exhaustion on a mechanical rowing machine while every function of their bodies were measured. I waited in vain for Steve to crack and stop, but he never did, he just kept rowing to the finishing time, grabbed a towel and dried off the sweat.

The other picture of Steve shows him leading out the UK team at the Atlanta Olympics; notice he carries the heavy flag and pole in one hand, holds his head high and marches into the arena. I had a lump in my throat as he did this as I imagined what his wife and family would be thinking. Yes, there can only ever be one greatest for me and that is Steve Redgrave, the Man of Steel.

The Barnsley Bride

Football is a funny game, and a passion of mine that gave me my career. The happiest moment for me through all the years of attending matches across the world was in the small stadium of Barnsley FC, a Yorkshire team who had never played at the top level of English football but in 1996/97 stood one match away from promotion to the Premier League.

The whole town was bedecked in red and white, the team colours; the ground was packed and the atmosphere was electric. No one would even contemplate losing, and the whole population of this small town appeared to be inside or standing outside the ground.

A line in the town newspaper had caught the attention of the press corps. A local couple with season tickets had planned their wedding on that very day. When the importance of the game became apparent, they changed the time of the ceremony so they could come to the ground straight from the altar. Sure enough, just before kick-off they walked down through the packed stand to a rousing welcome from their fellow supporters. To a man the photographers all ran onto the pitch in front of them and shot pictures of the pair in full wedding regalia kissing in the stand until the ref came over and ordered a stop.

It was a tough game that could have gone either way until the end, but Barnsley made it. On the final whistle the team were submerged under the weight of fans and press as they celebrated at one end of the pitch, I didn't join in but raced to the spot in front of the bride and groom at the other end of the pitch, I was rewarded with this incredible sight of the bride and groom with a scarf surrounded by a sea of red and white all singing, shouting and in the bride's case crying. Magic! This was the happiest picture I ever took in a football ground, and one that still fills me with pleasure when I look at it.

I will always have a soft spot for Barnsley FC, even though they only managed one season in the Premier League. This was their glory day.

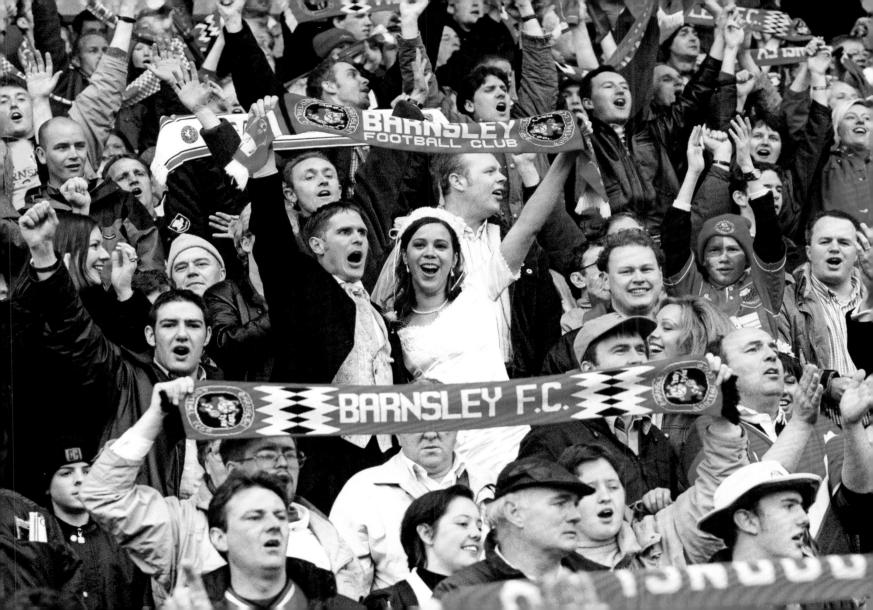

Tiger Woods

It was Tiger Woods' first British Open as a pro, and the big story in the lead up to the event was that he was to have his own police protection squad to guard him against the incredible excitement his participation had caused. Every photographer followed him for the first nine holes; they got loads of pictures of the shadowing police presence, but no incidents to talk of. One by one the photographers started to follow other golfers on the course. I sent my early films back to the wireman, and decided to stay with Tiger and his group of players. As the sun started to go down a beautiful Scottish sky started to build up, and I looked for a shot where I could get a silhouette of Tiger against the sky.

My opportunity came on the 17th tee, which was elevated with a five foot bank on the sides. I lay on this and had a beautiful shot of Tiger standing over the heads of the crowd, a complete silhouette against a blue and white sky and a very powerful image. It was used across the entire back page.

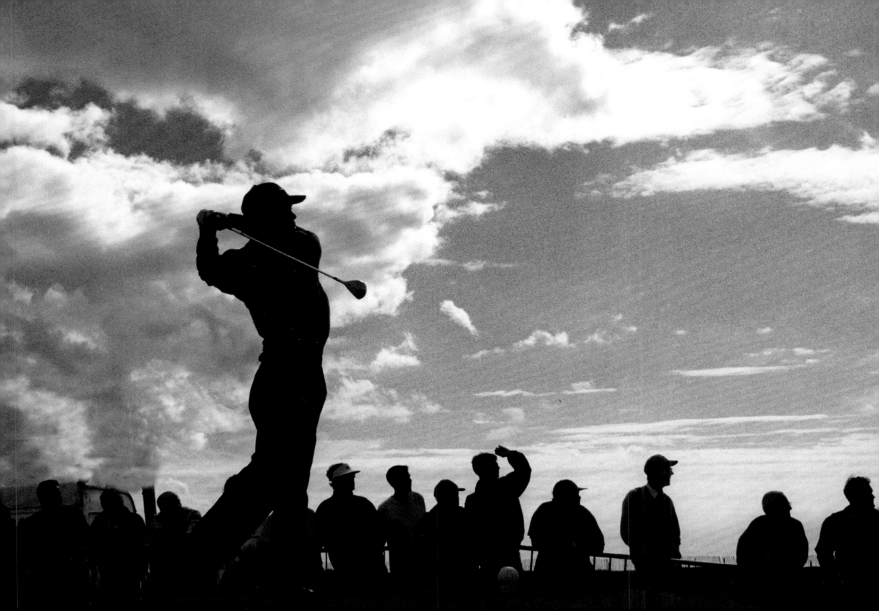

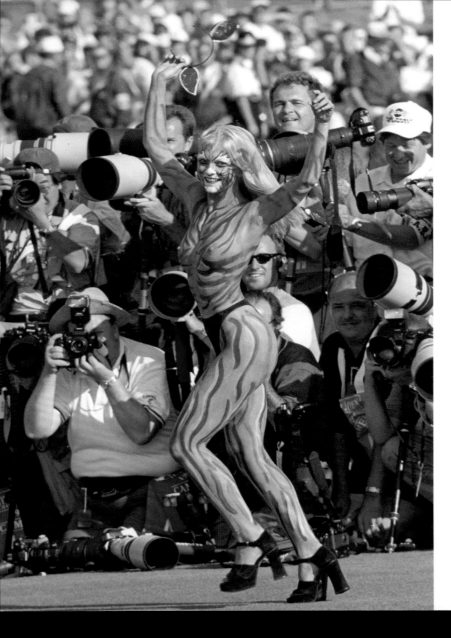

At the end of the tournament on the Sunday evening I had a picture of the winner as he received his trophy, then moved round the crowd to try for a shot of him against the wall of press cameras. As I moved through the crowd a young girl clutching her Burberry mac close to her body pushed past me and made for the side of the presentation area. Her face was made up to look like a tiger. She pushed to the side, dropped her mac and revealed full body tiger make-up, a G-string and nothing else. She had come to meet Tiger, and as she danced and laughed across the press area, causing quite a commotion, she realised he was not there; he hadn't won an award. Her strip was in vain, but I'm told the local magistrates saw the funny side of it and she got off with a warning.

Newmarket

It was one of those wonderful English summer days that we all remember…lousy! Under grey skies the rain was bucketing down all over the country. Tennis was off, cricket was off, everything was off! And the sports editor wanted a lively colourful picture for the back page to avoid the editor's favourite hate, a stock picture.

I had been down to cover a cricket match in London, but with not a chance of play he asked me to switch to a bog-standard race meeting at Newmarket and find something "colourful and different" that would grace the back page. When I asked for some ideas, the silence was deafening.

I drove up to Newmarket and joined a few of my disgruntled colleagues from other newspapers, all with the same brief, and all getting soaked on the photographers' stand opposite the grandstand on the course. I proceeded to shoot fast and slow shutter speeds and changed my position several times to try for the elusive 'something different'.

Racing in the rain is still very colourful, so it was all worth a try.

I decided to cross the track to the stand side and as I did so I noticed the finishing post; it was the old fashioned variety, a huge circle of red with the centre cut out. My memory went back to a picture I had admired as a youth, taken at Henley Royal Regatta, with the winner of the single sculls rowing hard for the post, taken through the empty centre circle.

I told the others I was off for a cup of tea, crossed the track again and made my way back away from the finishing post. About 50yds behind the finishing post was the stable lad's stand, a small stand where they watched the race before running onto the course to claim their horses for the lead in. On a 600mm lens it was perfect, with just the right amount of elevation for me to look straight down the course.

The next race was a distance, so the finish was on the far side of the track; I let this one go and waited for the next race

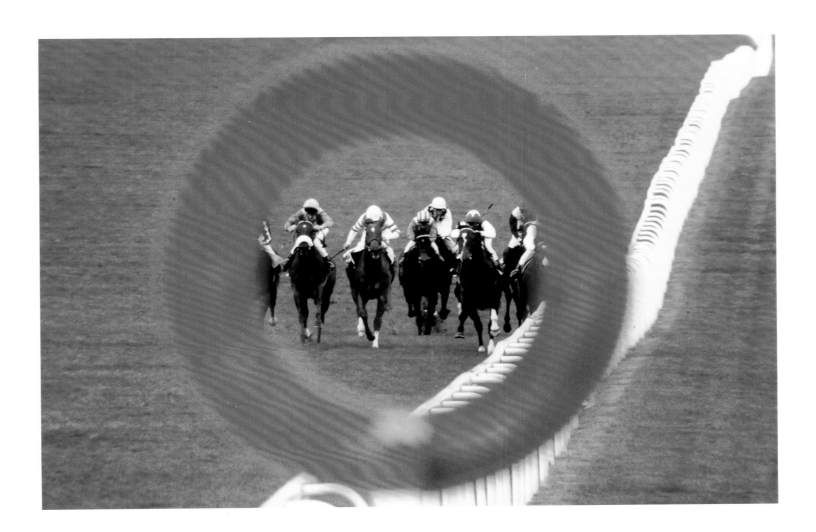

which was a sprint straight up the course on the stand side. As soon as the announcer called "they're off" and the crowd started shouting, I nipped up onto the stand and let the motor drive run. It was ideal for me, a small packed field with the winner in the centre.

I had time to take the picture back to the office, process and get it printed, then glow as first the sports editor and then the editor himself sang my praises. If I didn't have a big head before, I certainly had one then!

The picture won several sports picture competitions; it was shown on TV and syndicated all round the world. For the next meeting at Newmarket the post was changed to a solid circle to stop anybody else trying it.

Moldovan orphan

In the mid-nineties England were due to play Moldova in the capital Chisinau in a European football match. We flew out with the players and FA party as usual, and I was surprised to see a *Daily Mail* news reporter on the flight. He told me he was writing a feature on the poverty of the country, and I didn't give it a second thought. Moldova was the poorest country in Europe; even our hotel, the best in the capital, reeked of poverty.

On the second day, after shooting various training pictures, I was contemplating a bit of sightseeing when the news reporter came to my room and told me we were going out with a local charity worker to a small orphanage outside the city. The worker claimed children were being left to die in a basement room for lack of food and medicine.

I had always tried to avoid photographing other people's misery, so my first reaction was to say "no, I am not going"; we had also been warned that our entry visas only allowed us

access to the city centre, and that anybody breaking these rules would be arrested and deported, so I wouldn't be covering the match.

He explained that the office were aware of my feelings, but on this occasion I would want to uncover a story that could only do good for the orphans, and I was the only *Daily Mail* photographer in the country. Hobson's choice!

The local contact arrived in an old Russian car, I hid my cameras under a coat in the boot and off we went. He talked and bribed our way out of the city, past the military roadblocks and then drove for about an hour to a small village and pulled up outside what looked like an old military building.

The manager of the orphanage was shocked when we knocked on the door and walked straight in. He had a staff of local women who did their best for the children, and they tried to take us into a first floor office. The charity worker who had brought us would have none of it; he led us straight

down the stairs to the basement, and opened a door to a large room.

The scene that hit me as we walked in will stay with me for ever: about twenty young children all either mentally and/or physically disabled just lying on cots with no bedding, covered in their own filth. Some were crying, some screaming, and some were just staring into space. The stench was sickening and hordes of flies were everywhere, landing on the children and their meagre bedding. All of the children were freezing as the room had no glass in the windows. Hell would be too kind a description.

As the whole point of visiting this disgusting place was to bring it to the notice of the Western world, I had to steel myself to enter, ignoring the dreadful stench and flies, and take some pictures that the paper would be able to use without offending the readers over their breakfasts. I decided not to use a flash as the effect of this on these poor children could be catastrophic. I worked with what little light was in the room, photographing various children. I kept coming back to this young boy, quite a good looking boy, who just lay staring into space, not aware of the flies, stench and miserable surroundings.

We were told that there were other orphanages like this all over Moldova; it was normal for parents of affected children to just abandon them in the streets or in places like this. We were invited to the manager's office for coffee, but I was too upset to talk. I left the building and walked to the car and wept; I don't know how I avoided vomiting. The plus side to this was that we had the paper faxed to us the next morning with the full story and pictures, and we showed it to Glen Hoddle and the FA officials. They immediately organised a friendly match at Wembley with all the proceeds going to the orphans; the generous *Daily Mail* readers chipped in with lots of money and the paper made a donation. My pictures were donated to the charity in England to help raise funds and publicise the dreadful conditions in this poor country.

I was asked to return to the orphanage with a Christmas convoy of food and presents for the children. I refused, as I will never forget that day or the frustrated rage and stress that built up in me when I thought about this happening in this day and age. I could not have taken another visit.

Introduction – The 00s

In 1999 my health started to give. I accepted a "golden handshake" from the editor and prepared to go back to freelancing. After thirty seven years my days with the *Daily Mail* were over. I then moved with my wife to Ipswich in Suffolk, a small market town that I had visited many times in the course of my work to photograph Ipswich Town FC. We bought a house on a small golf course, and I imagined a quiet peaceful life away from the Street with the odd game of golf.

Of course within six weeks I was going mad with the sheer boredom of the beautiful countryside. I had spent almost 50 years working on Fleet Street and I am afraid I missed it very badly. So I looked around and started shooting cricket for the *Sunday Telegraph* in the summer and football for the *News of the World* in the winter. The *News of the World* wanted me to cover the lower division football, which suited me down to the ground, bringing me full circle to when I first started my career at a Leyton Orient home match.

I also started shooting feature stories for the papers and magazines, which were reasonably successful.

Wallace

Wing Commander Wallace was a wonderful man in his nineties but still flying his autogyro at his home, an old manse in Norfolk. I spent several blissful days with him. His house was a treasure trove of old WWII flying memorabilia, and he had his own small airfield, with a large hangar filled with his beloved autogyros led of course by "Little Nellie", the autogyro he had flown for the James Bond film *You Only Live Twice*.

He also had some extraordinary small working pistols that he had made himself; he was always surprising me with his gadgets as we toured his house. He was still the proud holder of eight world records and had held 34 in all, and he was trying for more when he suffered a bad crash; a few years later he sadly died. He would have made a great James Bond himself.

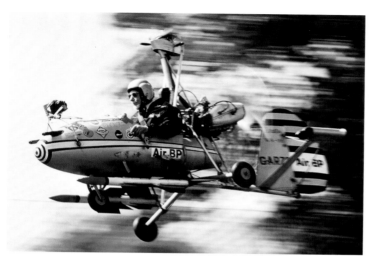

Wing Commander Wallace, taking off in "Little Nellie"
with my camera fixed to the front of the aircraft, to shoot
some 'selfies' over the Norfolk countryside.
He would have made a great "James Bond" with his
RAF background and a joy of life even in his nineties.
Note his left hand working the camera release.

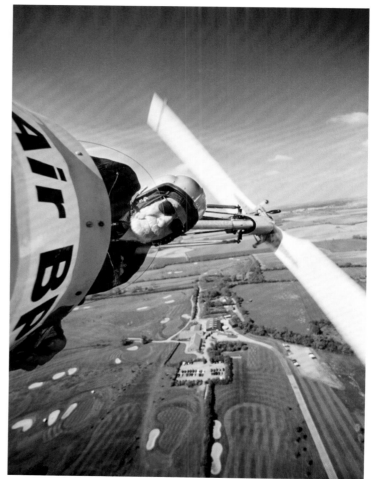

Terrence

Terrence the white Arabian stallion came from a request from the *Daily Mail* pictures desk: could I get them a good 'hot weather' picture that didn't include bikinis, ice-creams or crowded beaches? The whole country had been suffering under a heatwave for some weeks, and all the above ingredients for hot weather pictures had run their course. On a showground near me in Ipswich a travelling show devoted to horses called *Spirit of the Horse* had set up and were giving shows. I went and met the lady running the show – Nikki Fossett of the famous Fossett Family Circus – and asked for her help in setting up a picture of one of her white horses.

Against a background of dark trees, I wanted a white horse walking on its hind legs, a trick it did in the show, with a curtain of backlit water drops in front. I promised her the use of the picture for her show if she wanted it, and she agreed. She brought out Terrence, the star of her show; he played Pegasus the Flying horse, complete with feathered wings. The water was to come from a young stable girl with a hose fitted with a sprinkler. Both Nikki and I stressed on her the importance of *not* letting the cold water hit the hot horse, just spray it in the air. Nikki would encourage the horse to rear up and walk from about six yards away. We were set.

I retreated about 50 yards back to shoot on a long lens and shorten the distance between horse and water. I set the camera on motor drive and fired off a couple of shots as Nikki walked slowly backwards; the girl sprayed the air, then turned and let the water hit the horse. Terrence spun towards the water, his mane and tail flashing in the sunshine. It was not the picture I was after, it was ten times better.

The *Daily Mail* paid me a handsome holding fee to use the picture when they wanted, but in the end they never used it. I don't know why. The deputy picture editor told me it was the best picture they never used.

Pregnant boxer

The very heavily pregnant young lady is Jane Allard from Great Yarmouth in Norfolk. I spotted her story in a local paper – she had just had a fight as an amateur when they found she was pregnant. Luckily, no damage had been done, and she was planning her first pro fight after giving birth. I spoke to her and her husband about copying the famous Demi Moore picture of a pregnant Demi covered by her hands; Jane would have the extra coverage of her boxing gloves.

I shot the picture in her front room in a make-shift studio of black sheets. Her husband was there as her dresser, studio assistant and chaperone. She liked the idea but was rather shy, so she draped herself into a housecoat and adopted the pose I wanted; her husband removed the coat, stood back, and we had it.

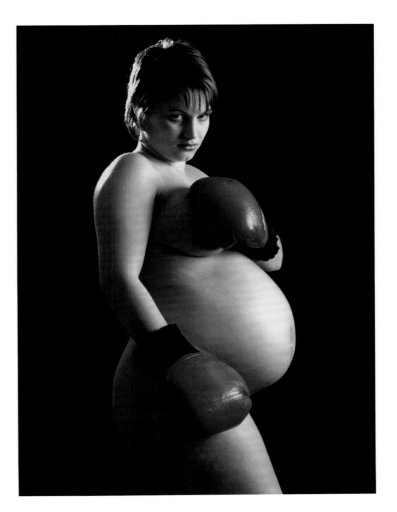

Robins

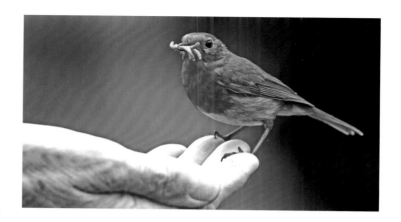

The pictures of the robins were again in the local paper, but the pictures were so bad I decided to re-shoot the pictures myself and sell them. The story was of a man who had trained some robins in his back garden to feed out of his hand at the sound of an old bell hanging on the garden wall. I wanted to show the birds on his hand, feeding off mealworms, with him holding the bell to call them. I did this with a 600mm lens shooting tight; I even got one in mid-flight as it swooped off his hand. Considering I have always suffered from slow reflexes I was very pleased with this one. The *Mail* printed them all over a page three spread, and the next day the local paper I had cut the idea from bought them as well.

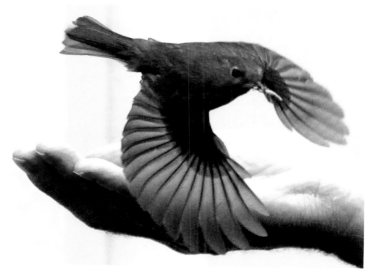

Pigs vs Seagulls

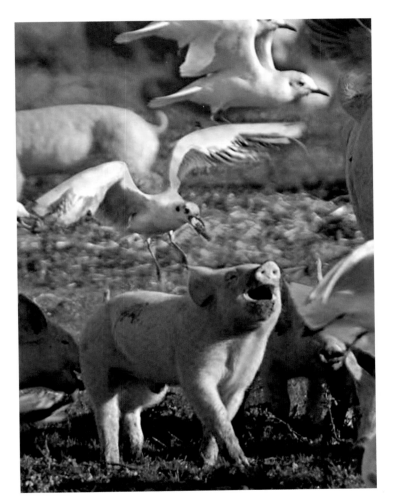

The pigs versus seagulls war came from feature in a local magazine which told that farmers' costs for pig feed had gone up 20% because the seagulls were eating the pellets. I contacted a local pig farmer and asked about the situation; he agreed with the figures and explained his frustration watching the thieving gulls helping themselves.

He agreed to allow me onto his land the next frosty morning (the gulls were more aggressive and hungry in the cold). I watched him putting the pellets down and could see a huge flock of gulls waiting in the next field. I hopped off his tractor and waited in the cold morning light; sure enough, within a few minutes of the tractor's departure, the thieves pounced. There were so many they filled the air, and I was reminded of Hitchcock's classic *The Birds*. I moved in and shot some close-ups of the piglets among the gulls, and one little fellow in particular who screamed with rage at the birds. It did him no good; the gulls simply grabbed a pellet, flew off and ate it, then came back for second helpings.

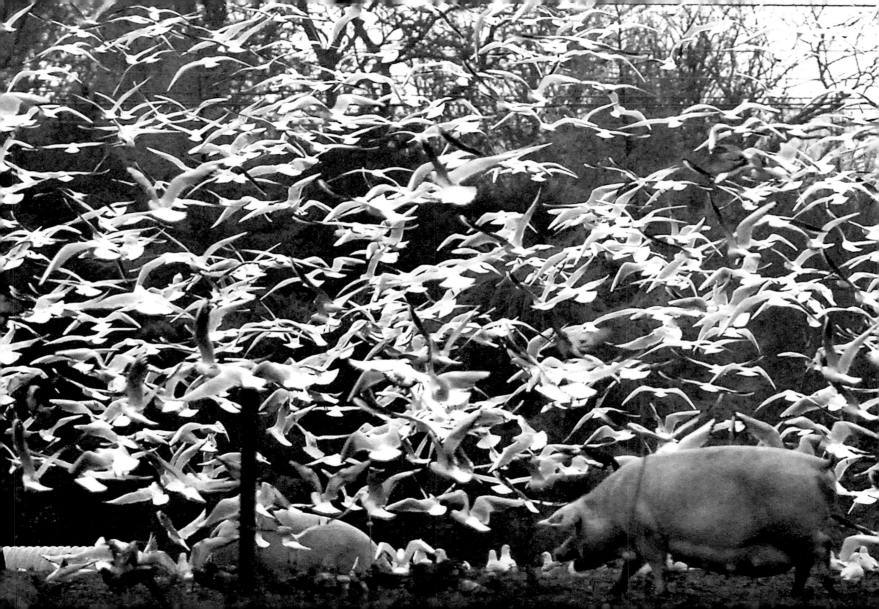

Babe in arms

This was one of the few pictures where I set out with an idea for a strong image for stock and actually came up with what was in my head. It was 2002; I was still in shock from my 'release' by the *Daily Mail,* and suffering because all the picture editors who had promised me work had let me down.

I had agreed to shoot pictures for a local paper charity competition for the "Face of East Anglia". I was introduced to Julie, the hairdresser who was doing the hair and make-up for the contestants. We became friends, and after the competition was over she asked me for a favour. Her nephew wanted to be a model; he had no money, but needed a portfolio – would I oblige?

I met him at her salon and realised he had as much chance of becoming a male model as I had of winning the pools. He was a body-builder, lumbering and not very photogenic, and he had loads of tattoos. This brought back an idea I had had many years before to photograph a new-born baby in a pair of very masculine arms. This boy had the right arms, even down to a barbed wire tattoo running right round his upper arm. I told Julie I would shoot a portfolio for him, and by way of payment they had to find me a new-born baby that the mother would allow to be photographed. The deal was done.

In those days I was shooting medium format film for my stock work as I still didn't trust the quality of digital. We all arrived at Julie's salon, set up a black sheet background, shot the portfolio pictures for the lad and then it was onto the arm picture for me. The young mother got the baby out of the pram and gently laid her on the model's arm. We had pillows underneath for safety, and the mother crouched just out of shot to keep an eye on her offspring. It was a fantastic contrast between the innocence of the baby's face and the brute strength of the arm.

I shot a couple of rolls of film then we called it a day. When the film was developed, I was very upset; the small

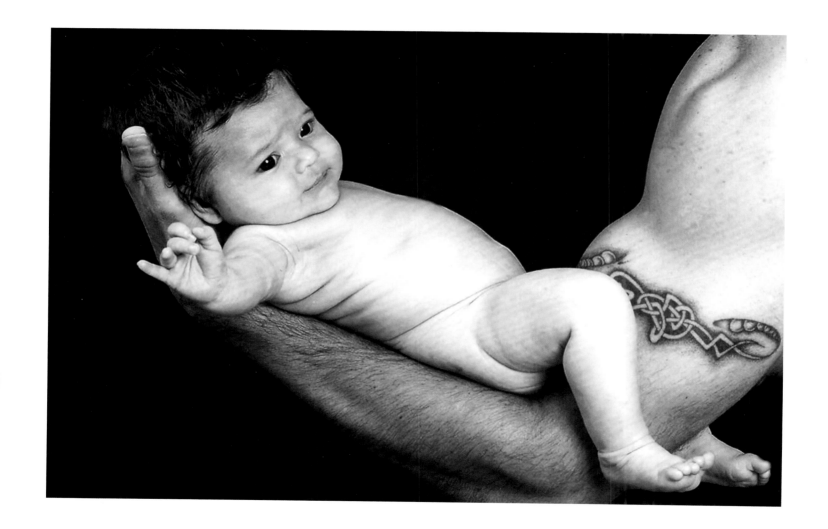

slave flash that was placed just behind the baby's head to add a little rim light had failed to go off. I decided the picture was a failure and that I would shoot it again when I next could. The opportunity never arose; the model had left for London, and we kept passing each other like ships in the night.

My wife had more faith in the image than I did and kept telling me it was a really good picture. The more I looked at it, the more I agreed with her, and at the end of the year I entered it into the UK Photographer of the Year competition. I still thought it ridiculous for one picture to get a UK award, but the image worked well, so I decided to give it a go. It made the finals, and my wife and I were invited to the Guildhall in London for the presentations. I wrote the date in the calendar and waited for the day. The day before the presentations we were playing in a bowls match at Hollesley. I walked outside for a bit of fresh air when my phone went. It was my son, Peter, ringing to congratulate me on winning the competition. I told him he was being a bit previous, as the awards were the next evening, but he assured me the news was out on the web. I was the UK Features Photographer of the Year and I had missed the presentation! A swift call to the organisers the next day confirmed they were holding the prizes for me, and they invited me to a showing in Chelsea of all the winners.

The local paper ran a half-page story on the debacle, but the bowls club all agreed I had been in the right place: bowling for Nacton.

Diana: A short sad life

The pictures and stories in this book are roughly in the order in which they occurred, but this section is made up of three pictures I took of the tragic Princess Diana during her short sad life.

The first is a shot of her under her heavy veil as she waited patiently just inside St Paul's Cathedral as the Emanuels and her bridesmaids tried to straighten out her fairy-tale dress, which had become horribly creased in the coach ride. With her ailing father standing beside her and David Emanuel offering words of encouragement, she gave a dazzling smile, which is something we didn't see too often after the wedding.

The second shot was taken as the family had a day out at a charity polo match at Ham House. They were using a Land Rover as a base and it was parked discretely in a corner of the field. Security was very tight, and all of us 'snappers' were being kept well back in areas where it was difficult to get a

shot. I soon tired of being hustled by the guards and decided on a different approach. I attached a "doubler" to my 600mm lens, and moved backwards to a spot approximately 100yds from the family, where through the parked cars I could see them and work without aggro.

The quality always suffered with those early doublers, but I managed to get this happy family shot of Prince Charles laying down the law to his two sons as Diana caught sight of me among the parked cars and laughed.

The last picture bears out the old soldiers' advice: never volunteer for anything. It was Princess Diana's funeral, and as chief sports photographer I was only down to cover sport, but a plea from the picture editor for 'all hands on deck' saw me putting my hand up. I was given a 'roving' assignment and not the rota position I had expected with its guarantee of pictures. I decided to position myself halfway down the Mall between Admiralty Arch and Lancaster House, where

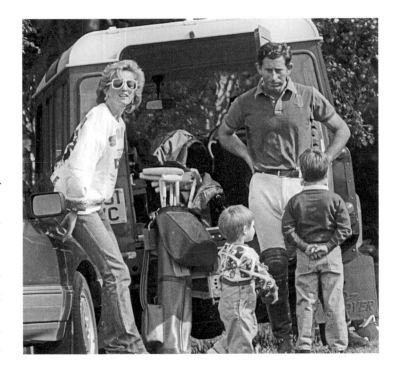

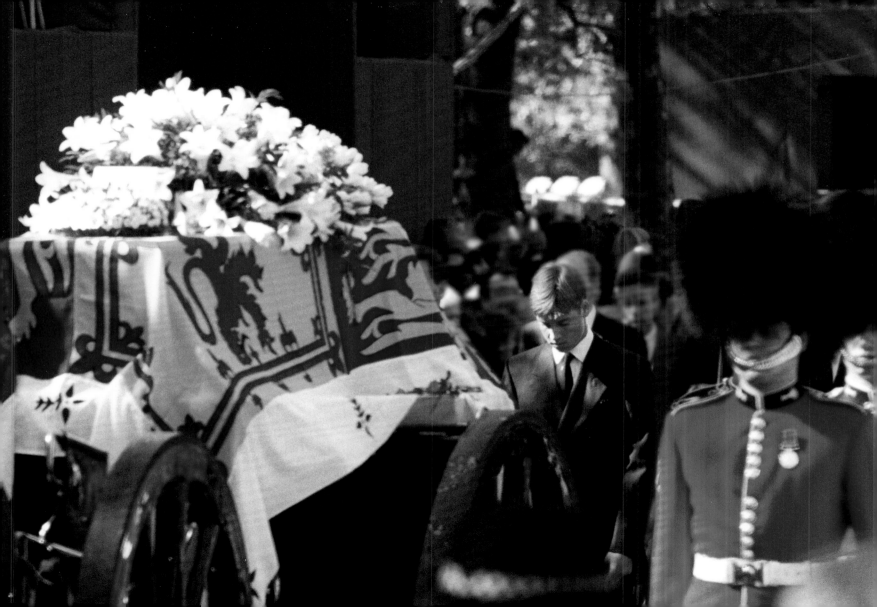

the princes were due to join the procession behind the gun carriage and coffin. I would have two chances from here: a long lens shot of the coffin and gun carriage with hopefully Prince Charles behind, and a wide angle shot as they marched past the spot. I had carried a pair of steps with me to get above the crowd.

As the procession moved down the Mall towards me, I balanced precariously on the steps with my heavy 600mm camera and lens, and the other camera over my shoulder. I wasn't helped by a enthusiastic young American who clambered up the empty three steps at the bottom. There was no time to shoo her off, and the Mall was silent for the funeral procession. I never did see Prince Charles clearly on the long lens, but for a magical second Prince William was clear of everybody else, and I managed three exposures of this scene.

Whenever I look at these pictures I am reminded of how short and tragic her life was. I still have mixed feelings about the manner of her death and I find it hard to believe it was a royal plot. Whatever the circumstances her loss was a great tragedy that inspired the greatest public mourning to any royal death.

Final Words

I was once introduced to a top "society" photographer at a photo call in London. When it was explained to him that I was a Fleet Street photographer, he stated rather condescendingly, "Oh you're a jack of all trades!" I thought for a moment and then said, "If that means I can do everything you do, and more, then yes I am!"

Taking you through my extraordinary life in Fleet Street, it occurs to me that being successful on the Street meant being just that: "a jack of all trades", and not a master of none but somebody who was able to get pictures of any subject at any time. After a few years on the Street, I started to view the world through the oblong shape, working out the right angle for the best pictures; I still do. Growing up through the plate camera years to the Rollieflex, then the Nikon 35mm film cameras, and finally the massive change to digital, I had to learn to cope with changes needed for each of these formats, and get the pictures back to UPI or the *Daily Mail*.

It was not always easy. In the early days we would work from photo agencies round the country. If we were not near an agency or a hotel, we would knock on doors in the streets surrounding the grounds and hire the use of a room and a telephone line and work from there. As the amount of money in sport grew, so sporting venues began providing special wiring rooms for the photographers. One of the first, and one of the best, was provided at Old Trafford by Manchester Utd., who quickly realised they had to provide for the foreign photographers to keep in line with UEFA rules. They built a room big enough for fifty photographers to work side by side, with telephone points paid for by each newspaper or agency; there were lots of small darkrooms for processing films, and space for laptops on the desks. This was great for films, but with the advent of digital in the late 1990s, it all changed again.

When I left the Street in 2000 wiring was still being done from laptops that needed a power point and a telephone line. A

[Above] The Duchess of Cornwall sits proudly with the Desert Rats

[Left] Various pictures showing photographic skills I picked up during my career, these were used to illustrate school sports and shows

few years later I was attending a charity event in London and was talking to the Press Association photographer when he needed to move an early picture. I asked where he was wiring from and he laughed, took a card reader out of his pocket, attached it to his mobile phone and wired as we chatted. Progress!

All of these changes have had a remarkable effect on the photographers of Fleet Street. In their heydays all of the papers had large teams of photographers covering every kind of news, features, sport stories and anything else that was needed. The photographers fed their own personalities onto the pictures and stories and were proud to follow their images through the system to the final pages.

The picture desks of the national papers now have to deal with thousands of images showering on them from all corners of the globe; they all look the same, and it's rare to see a good exclusive idea from a staff photographer. So although I hated older photographers telling me, "we had the best years", I can honestly say that my generation did.

From 2000 to 2006 I did freelance work, shooting cricket for the *Sunday Telegraph* and lower league football for the *News of the World*. A serious heart attack in 2006 put an end to this, and I turned to one of the other great joys in my life: Orwell Park School, a top prep school in the village of Nacton, near Ipswich.

I first went there to shoot a feature on a special church service in the Parish church within the school's grounds. At the time I was suffering from clinical depression caused by the loss of my ability to work in Fleet Street; I missed it dreadfully. I chatted to the headmaster, and he invited me to help raise the school's profile through local papers and magazines, and the nationals if I could. This meant I was working in one of the finest historical buildings in the country, surrounded by 110 acres of beautiful countryside running down to the River Orwell.

I researched the history of the school and the building and discovered some fascinating facts. The house had been built for one of England's greatest admirals, Edward Vernon, the man who took Porto Bello from the Spanish. It was then sold to the Victorian entrepreneur Col. George Tomline, who founded the Felixstowe Docks, now the biggest container port in Europe. He was friends with King George V and Queen Mary; these royals and their courts were often entertained at the house.

During the First World War the house was a hospital for all ranks; the visitor's book has signatures from privates to royalty, and makes for fascinating reading.

At the start of the 19th century the first ever steeplechase was run by a bunch of Hussar Officers commanding the troops waiting for Napoleon's invasion. They settled an argument as to who rode the best horse by holding a race from Ipswich to Nacton church, dressed in nightshirts and caps to pick themselves out in the moonlight. This type of race became

popular and led eventually to Cheltenham and Aintree, the greatest tests of horses in the world. I recreated this race a few years ago with the aid of the school's equestrian team and some very willing mothers. We built fences in the grounds and the girls wore men's loose shirts and pillowcases over their helmets. We had extensive coverage in the local papers, horse magazines, and three slots on Anglia TV in the lead up to Cheltenham.

Another historic figure I recreated with the aid of the children was Margaret Catchpole. Born on the estate, she was the girlfriend of a local smuggler in the 1850s. She gained fame by stealing her master's best horse and riding to London in nine hours, no mean feat. We recreated the ride in front of the school and again had a very long piece on Anglia TV as well as good coverage in the locals and magazines.

Every year we welcome the Desert Rats Association to the site; their only UK base throughout the Second World War. They came here to prepare their vehicles for the D Day landings, and when they left many of them never saw England again. A few years ago the Duchess of Cornwall attended – her father was a Desert Rat.

So although I led a very colourful and adventurous life in Fleet Street, I am now working happily on a site that is quintessentially English. I really do see myself as Mr Chips. There cannot be many photographers who have organised their own steeplechase, or recreated history on the actual site on which it happened. When I cover cricket on the first's wicket, with the old clock tower ringing out the hours, halves and quarters, I recite lines by Rupert Brooke, my favourite lines in English poetry, 'Stands the church clock at ten to three? And is there honey still for tea?'

[Above left] 'Stands the church clock at ten to three?'
[Far left] Margaret Catchpole rides
[Left] Reron of first ever steeplechase

You may also enjoy these biographies from showbiz reporter
Mike Tomkies who turned wilderness author

BACKWOODS MATES TO HOLLYWOOD'S GREATS

Mike Tomkies

978-1904445-35-7

MIKE TOMKIES

MY WICKED FIRST LIFE

Before the Wilderness

978-1904445-83-8

'…this remarkable tale of a life that veers
between hobo and Hollywood, high society
and lowly life forms, before finally heading
off to Scotland to start afresh'.

Scottish Field